D0688698

# GLOBAL MODEL VILLAGE

# GLOBAL MODEL VILLAGE

The international street art of Slinkachu

Blue Rider Press
a member of Penguin Group (USA) Inc. New York

blue
rider
press

Published by the Penguin Group
Penguin Group (USA) Inc., 375 Hudson Street, New York, New York 10014, USA
Penguin Group (Canada), 90 Eglinton Avenue East, Suite 700, Toronto, Ontario M4P 2Y3, Canada (a division of Pearson Penguin Canada Inc.)
Penguin Books Ltd, 80 Strand, London WC2R 0RL, England
Penguin Ireland, 25 St Stephen's Green, Dublin 2, Ireland (a division of Penguin Books Ltd)
Penguin Group (Australia), 250 Camberwell Road, Camberwell, Victoria 3124, Australia (a division of Pearson Australia Group Pty Ltd)
Penguin Books India Pvt Ltd, 11 Community Centre, Panchsheel Park, New Delhi–110 017, India
Penguin Group (NZ), 67 Apollo Drive, Rosedale, North Shore 0632, New Zealand (a division of Pearson New Zealand Ltd)
Penguin Books (South Africa) (Pty) Ltd, 24 Sturdee Avenue, Rosebank, Johannesburg 2196, South Africa

Penguin Books Ltd, Registered Offices: 80 Strand, London WC2R 0RL, England

Copyright © 2012 by Slinkachu
All rights reserved. No part of this book may be reproduced, scanned, or distributed in any printed
or electronic form without permission. Please do not participate in or encourage piracy of copyrighted
materials in violation of the author's rights. Purchase only authorized editions.

First published 2012 by Boxtree
an imprint of Pan Macmillan, a division of Macmillan Publishers Limited
Pan Macmillan, 20 New Wharf Road, London N1 9RR
Basingstoke and Oxford

9 8 7 6 5 4 3 2 1

ISBN 9780399160745

Printed by Printer Trento, Italy

Book design by Slinkachu
www.slinkachu.com
www.little-people.blogspot.co.uk
Follow Slinkachu on Twitter @Slinkachu
www.andipa.com

ALWAYS LEARNING                                    PEARSON

# INTRODUCTION

The world is going to the dogs. You read about it in the papers every day. You see it on the news. The good old days are long gone and the only thing to look forward to is a steady decline, leading to the inevitable apocalypse.

Of course, the cities will be the first to go, overrun with illegal immigrants, violent gangs, paedophiles and foreign armies. Complete economic collapse comes next, followed by direct chemical and nuclear strikes. And all this while rising sea levels flood the streets. It's going to be a real pain in the ass and – look around you – it's practically happening already. It's going on, over there, right behind the Pepsi billboard!

But there are more immediate concerns for us, because the train is late and it's already 8.45 a.m. The baby was awake all night and the kids are blowing off school. Letters from the bank are stacking up, unopened, on the kitchen table. The view from the office window is another office window, one packet of cigarettes has become two, Facebook shows no Friend Requests and one side of the bed is always empty. And we are all waiting for those days when the sun breaks through the clouds and, for once, the city looks . . . perhaps not so bad after all.

This is happening in London and Beijing, New York and Moscow, in every city, in every Starbucks, under every CCTV camera. These are the real dramas, this is the real news.

Despite all our differences, this is what unites us, the 'little people'.

# GLOBAL MODEL VILLAGE

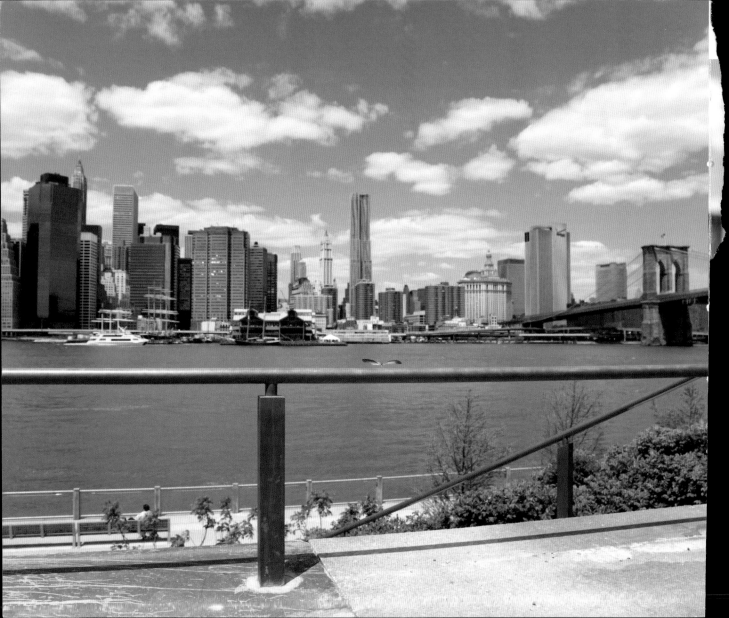

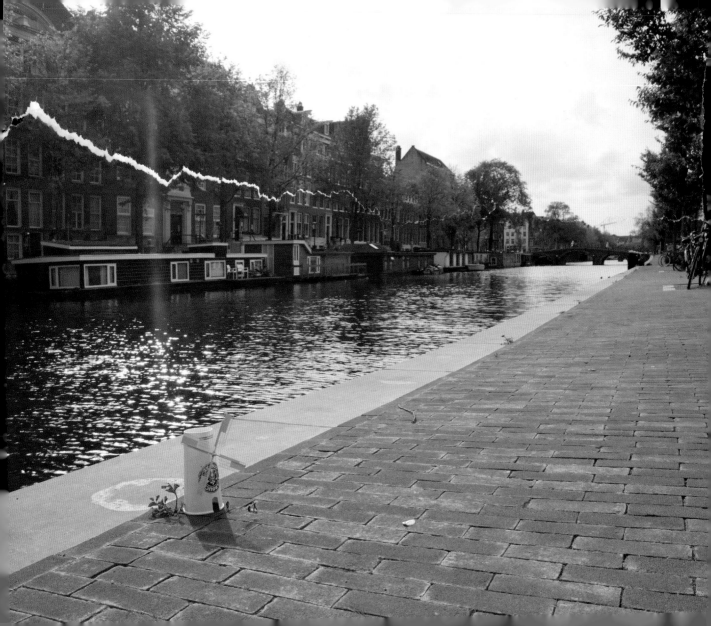

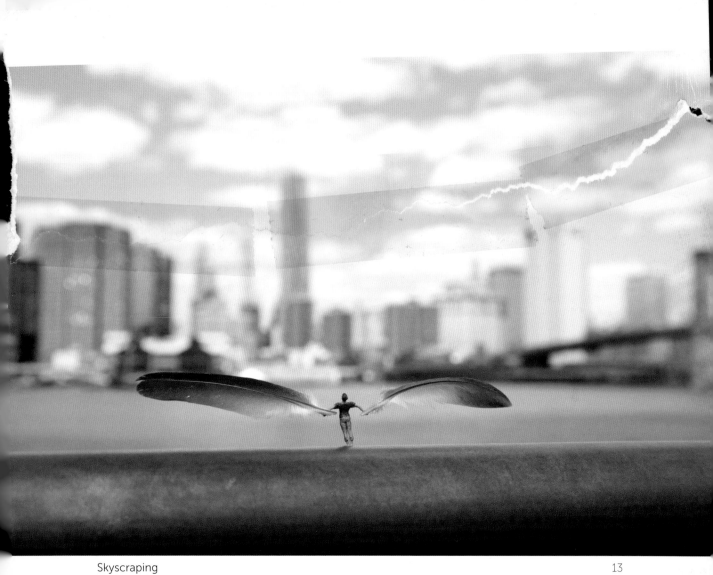

Skyscraping

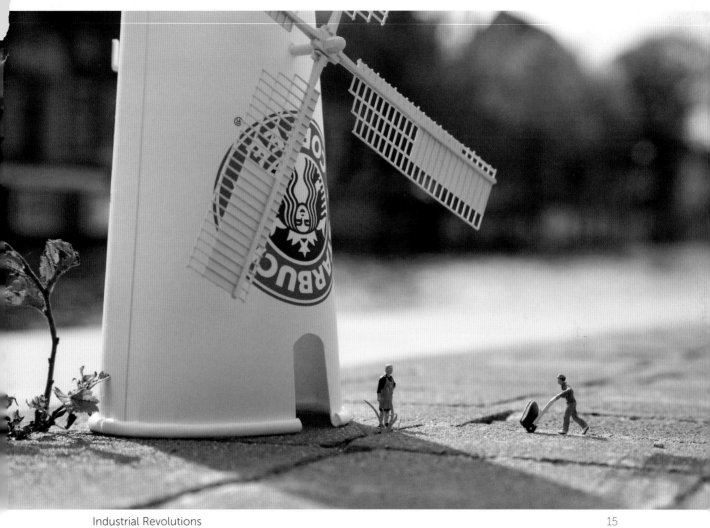

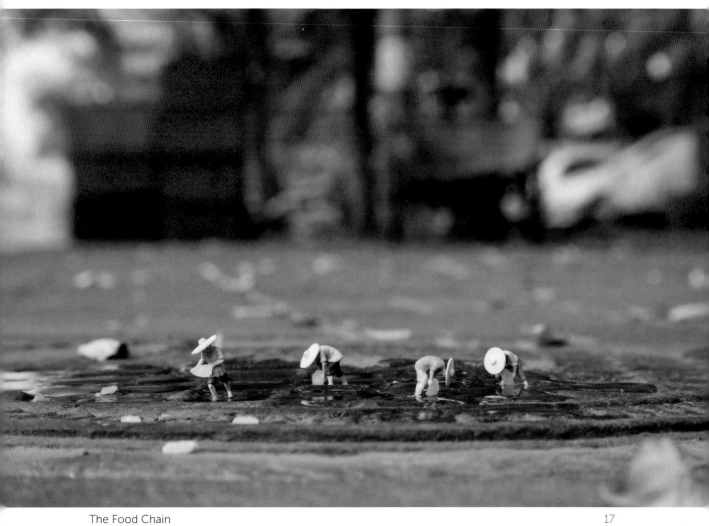

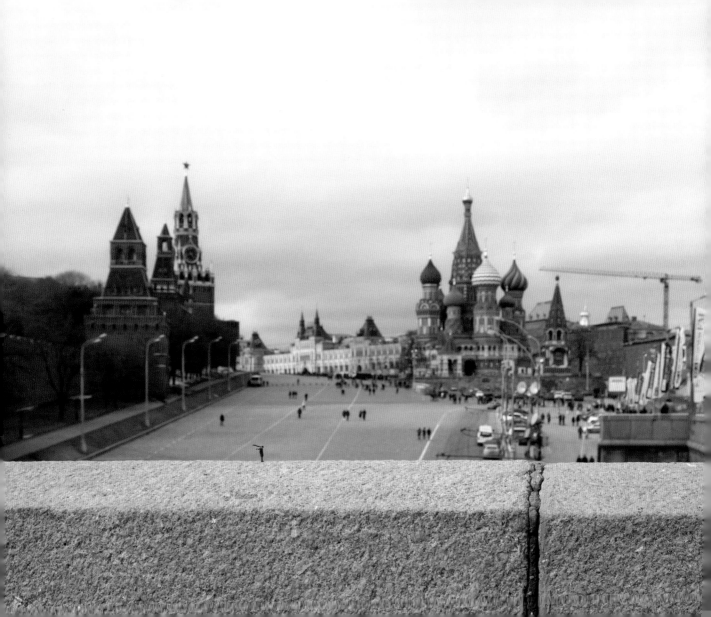

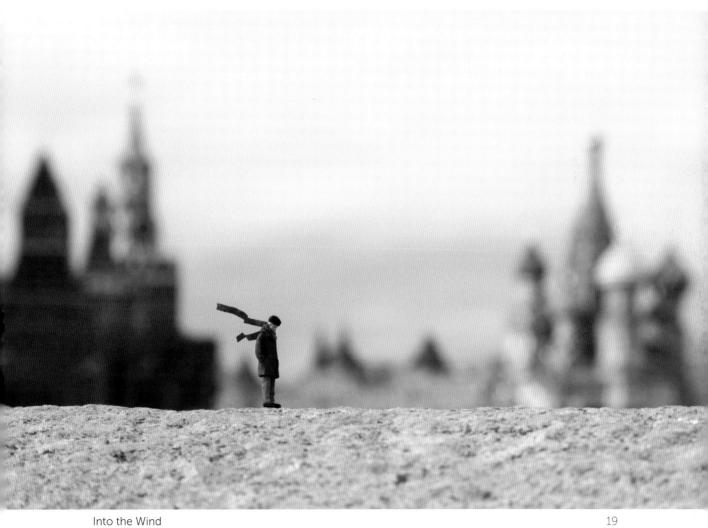

Into the Wind

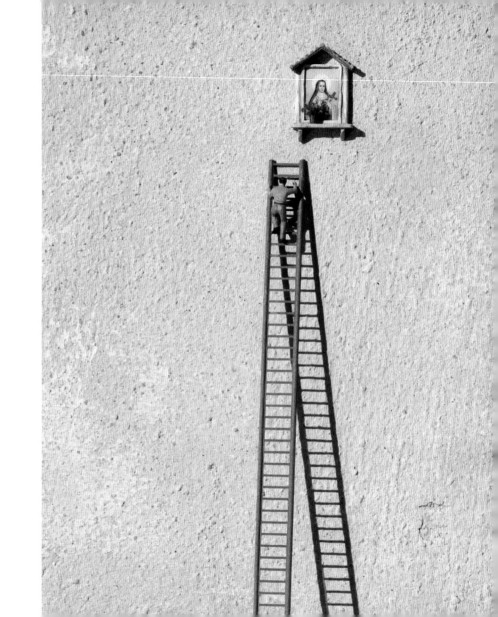

The Local Authority

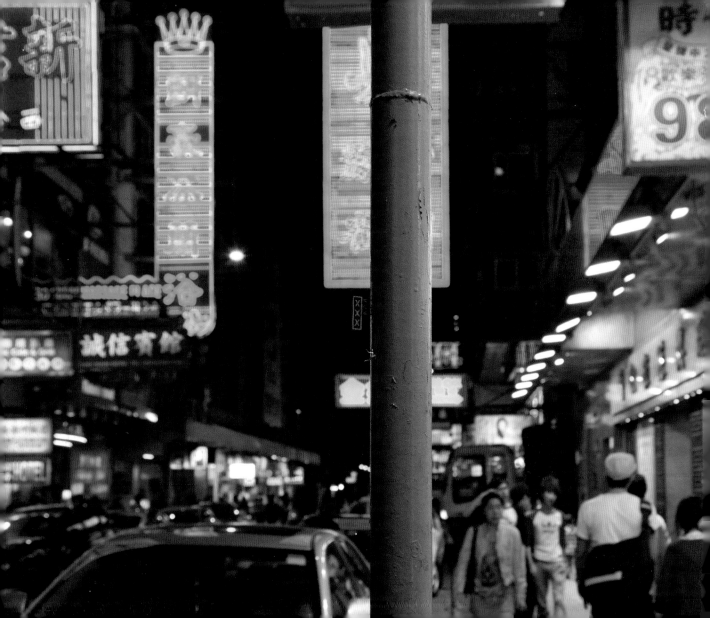

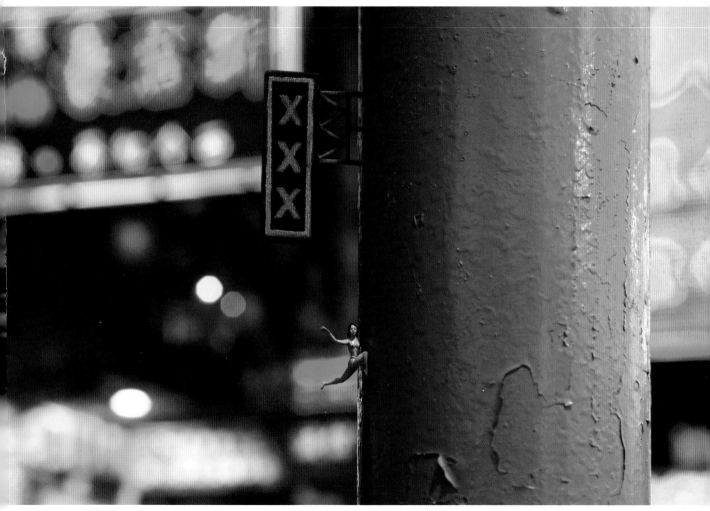

Hanging On

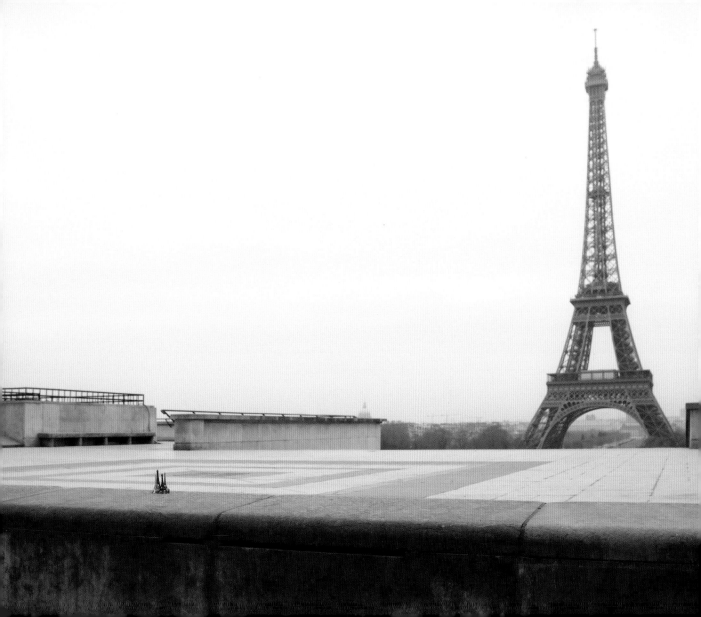

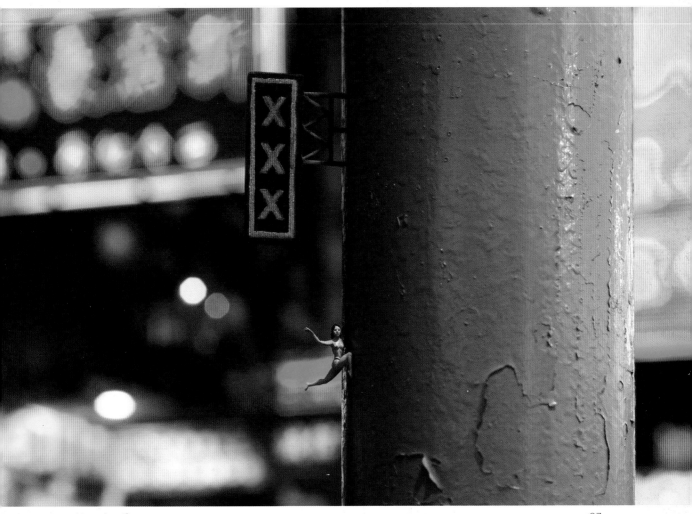

Hanging On

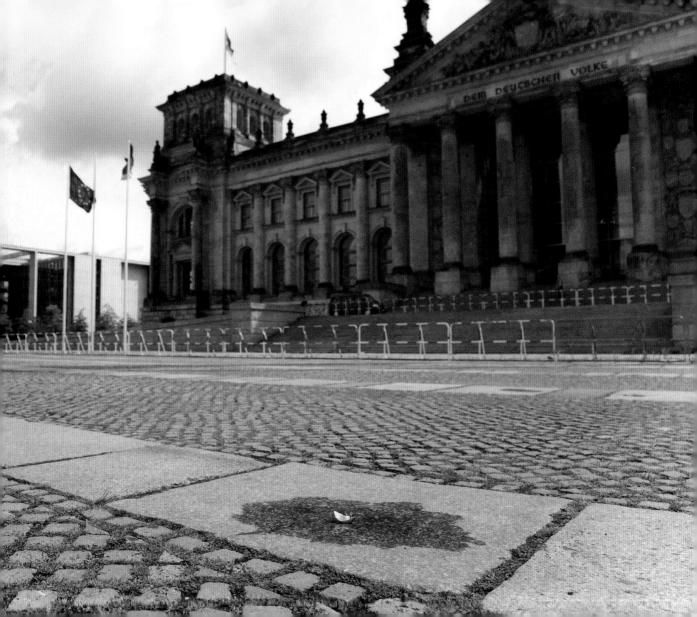

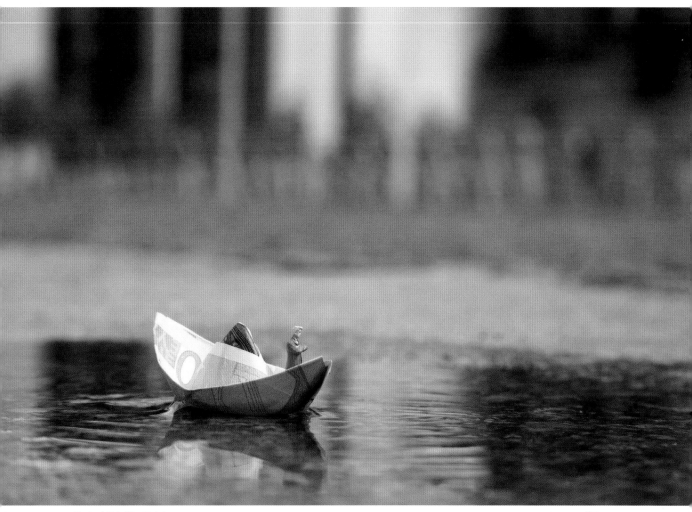

Early Mid-life Crisis

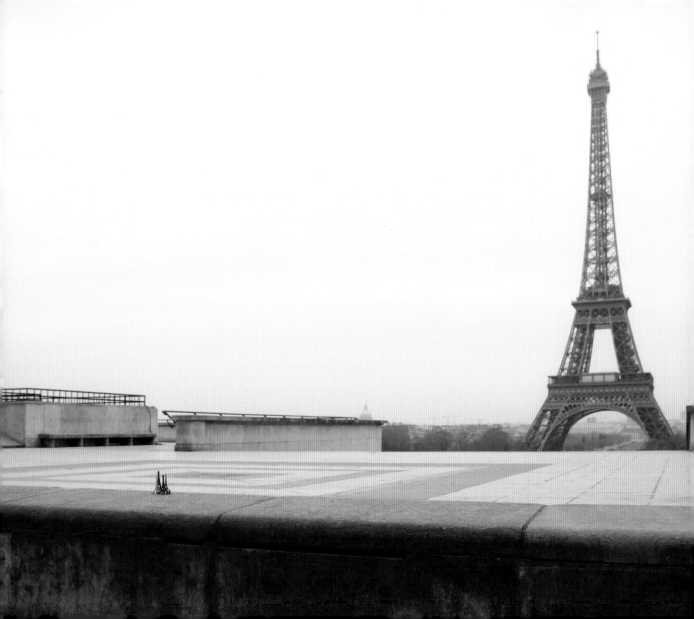

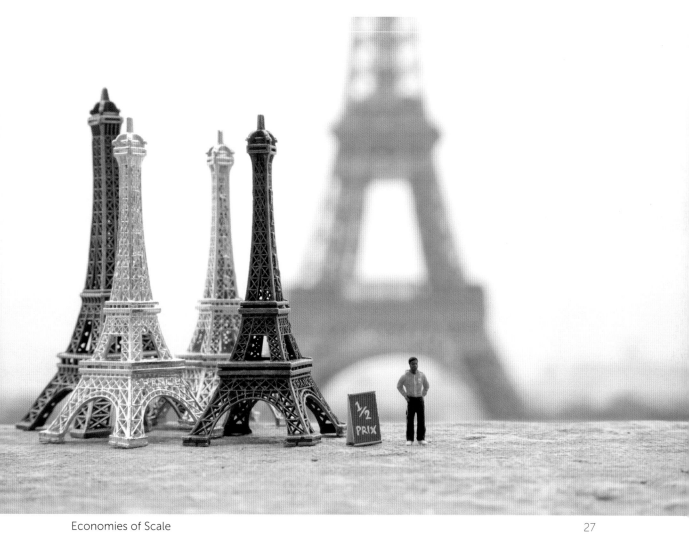

Economies of Scale

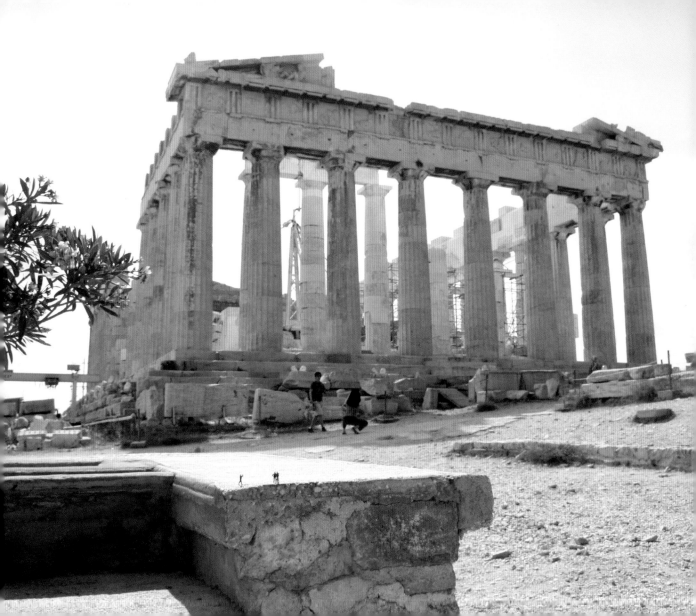

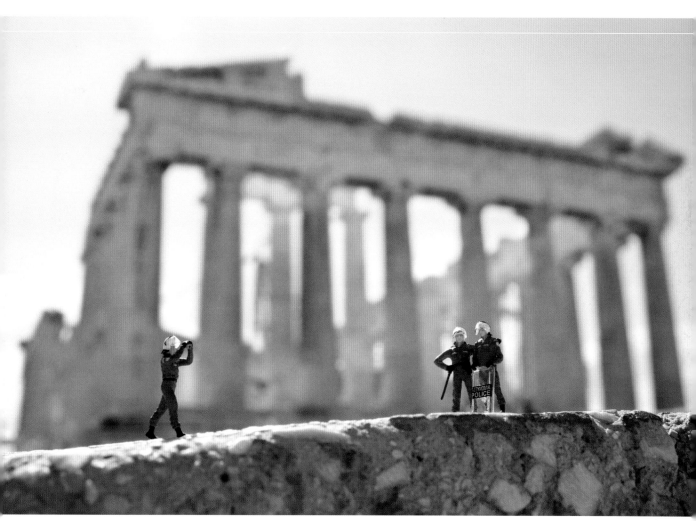

The Sights

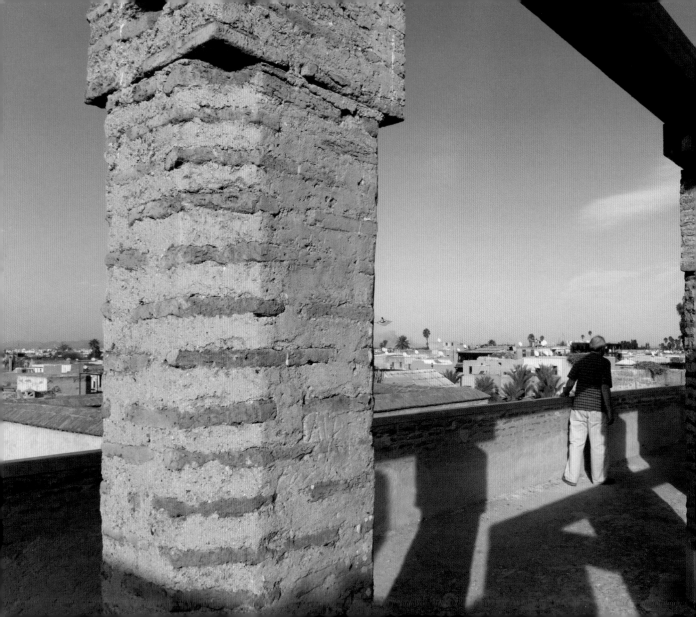

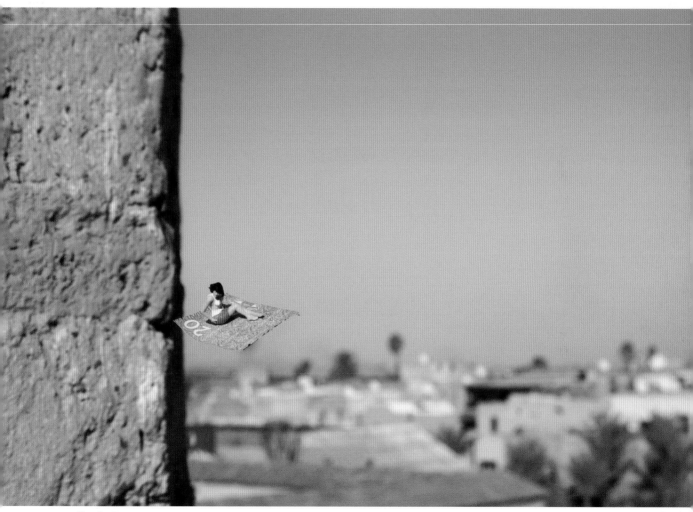

Single Journey

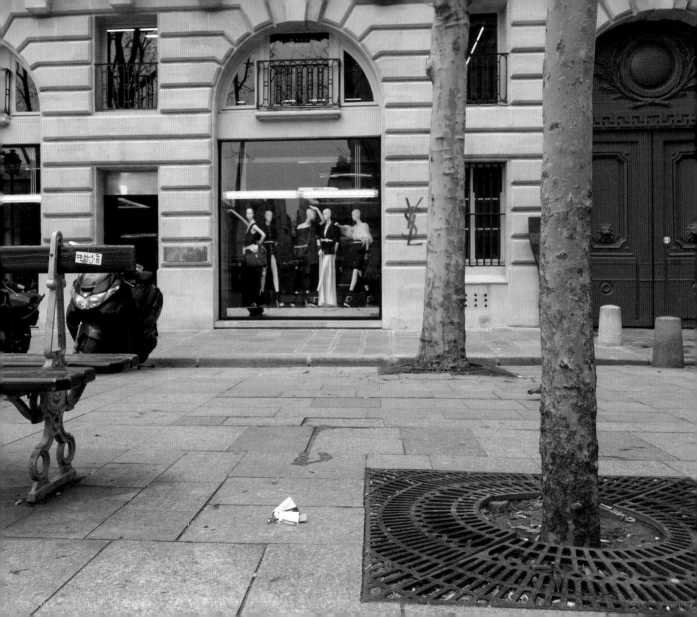

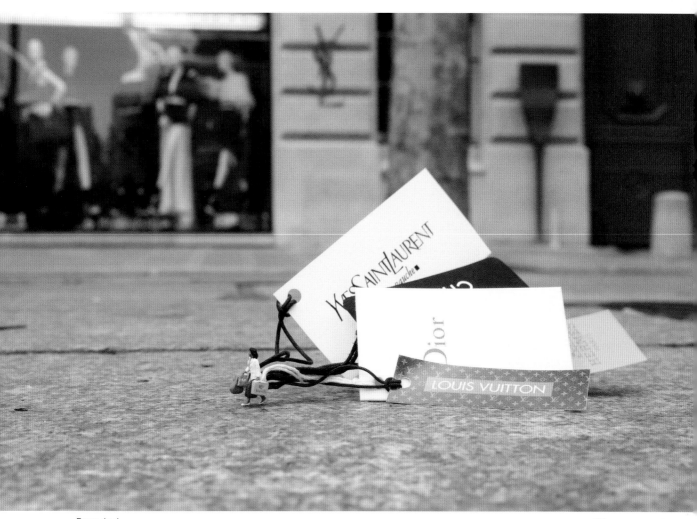

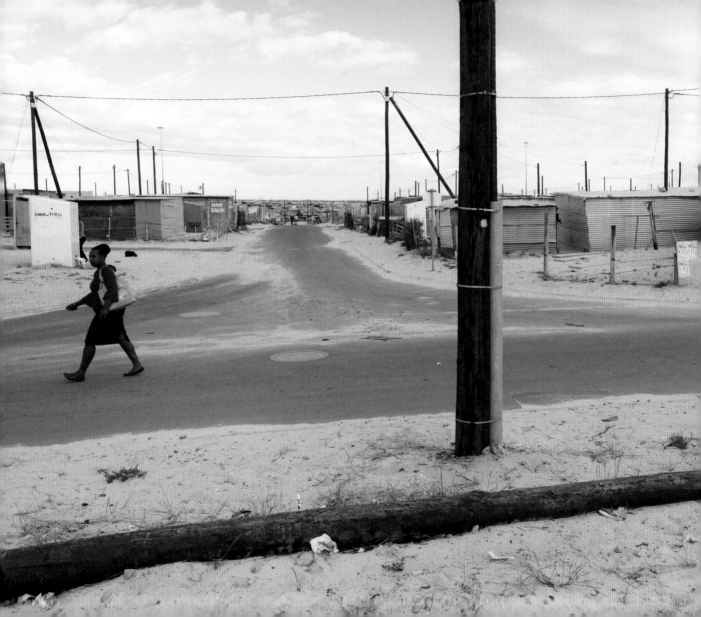

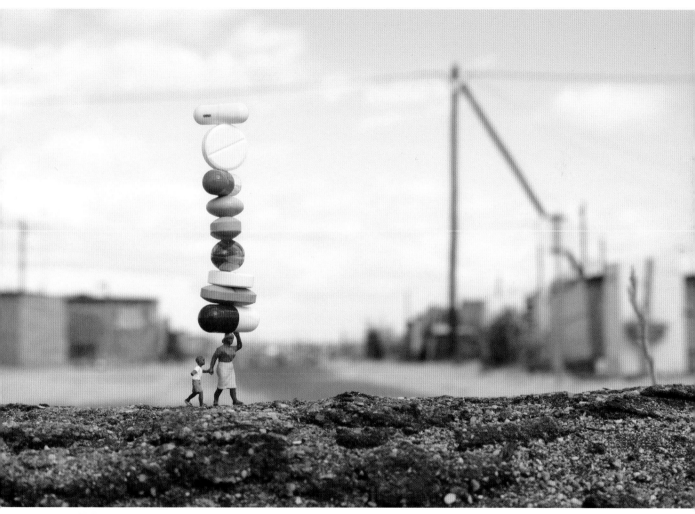

Balancing Act

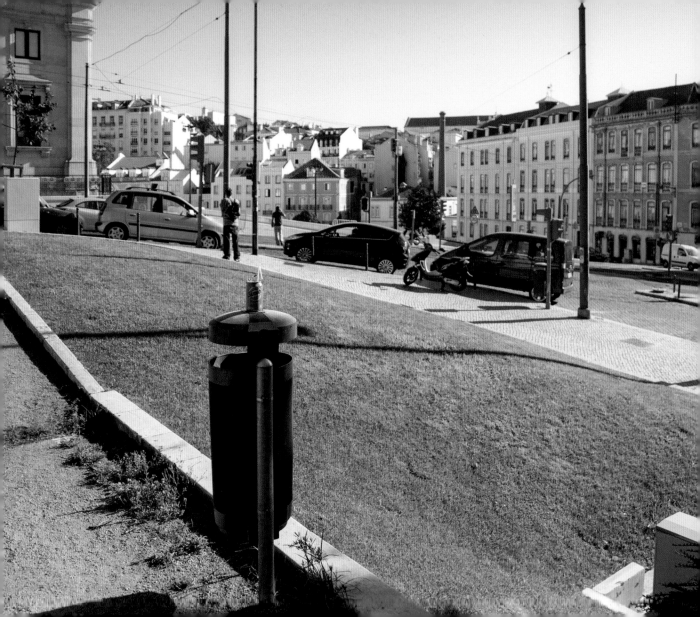

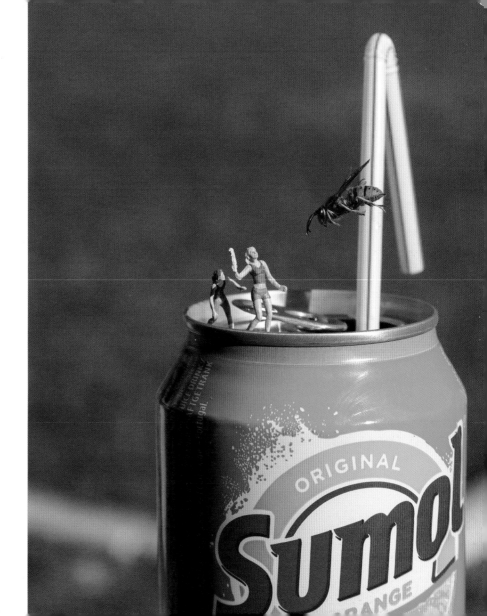

Pest

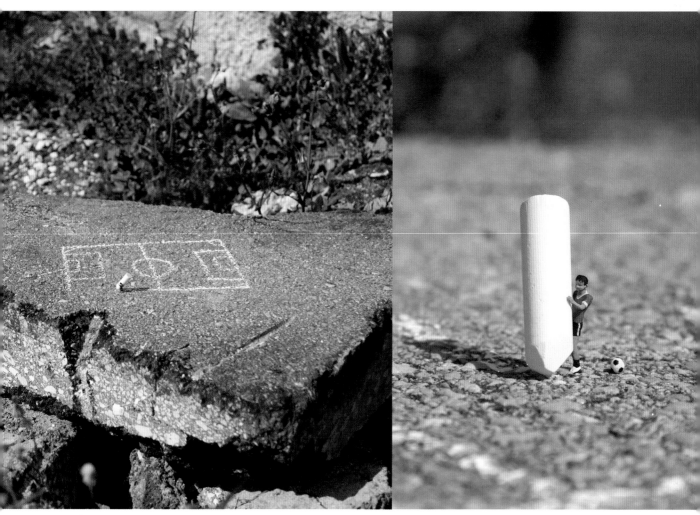

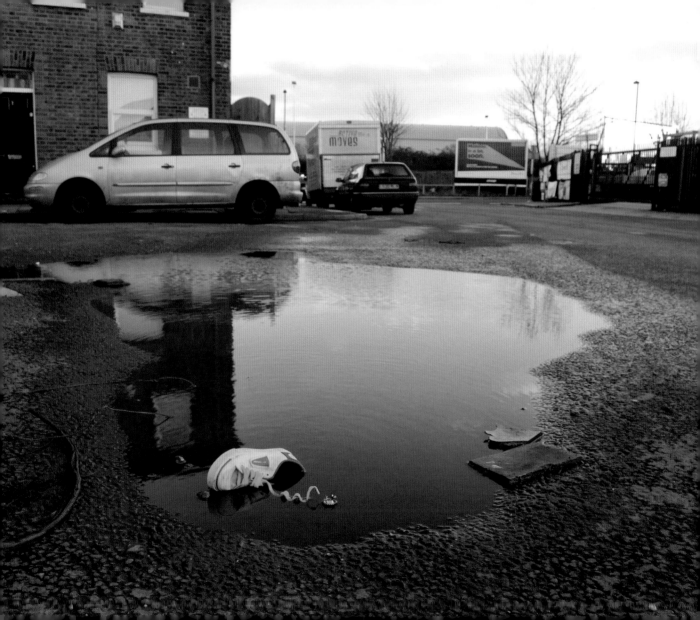

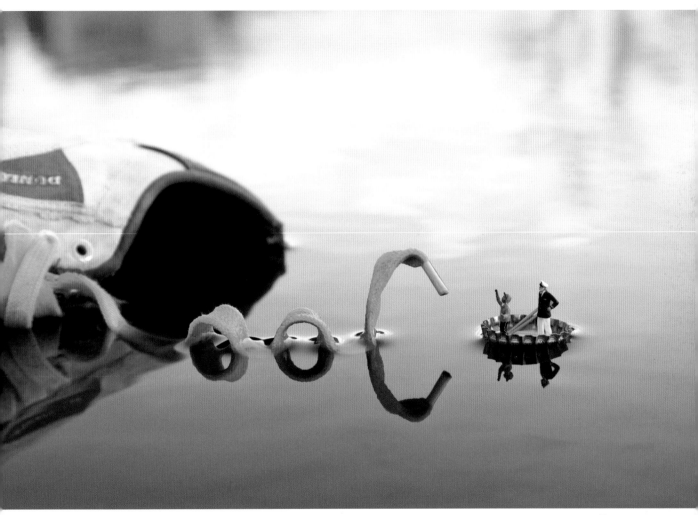

Fantastic Voyage

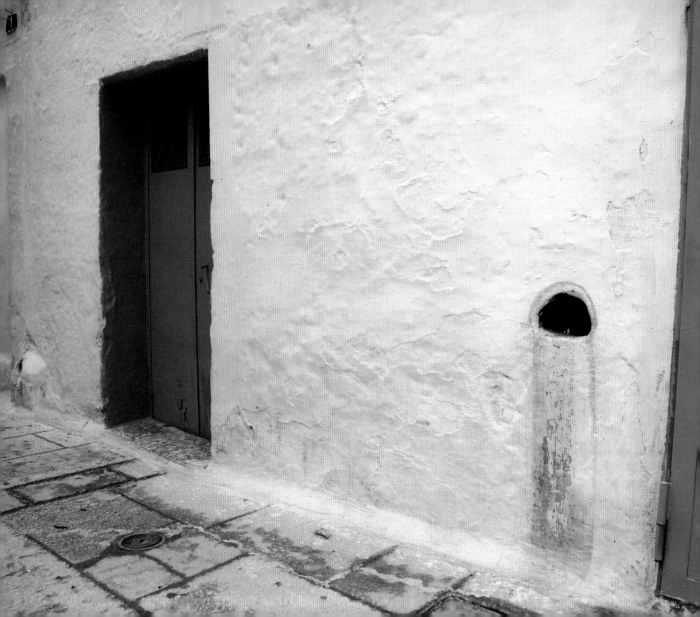

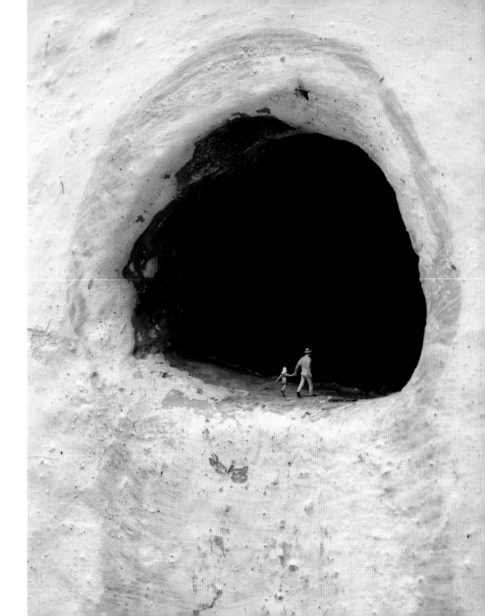

The Cave

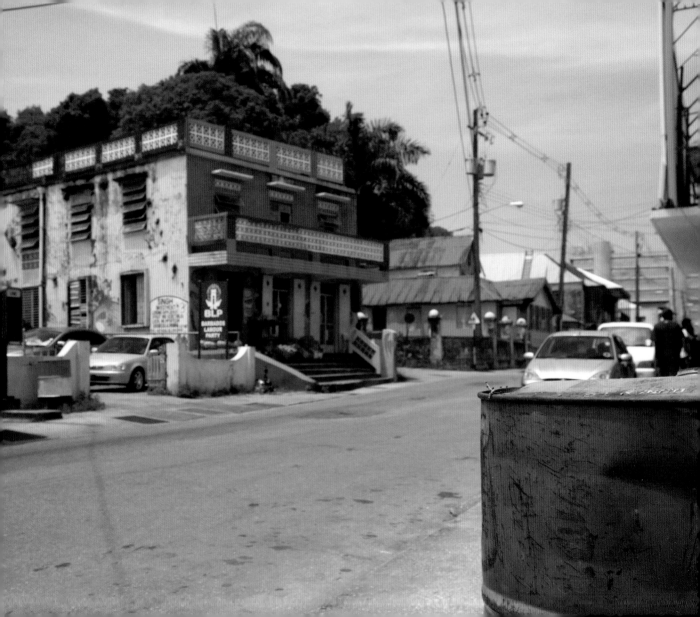

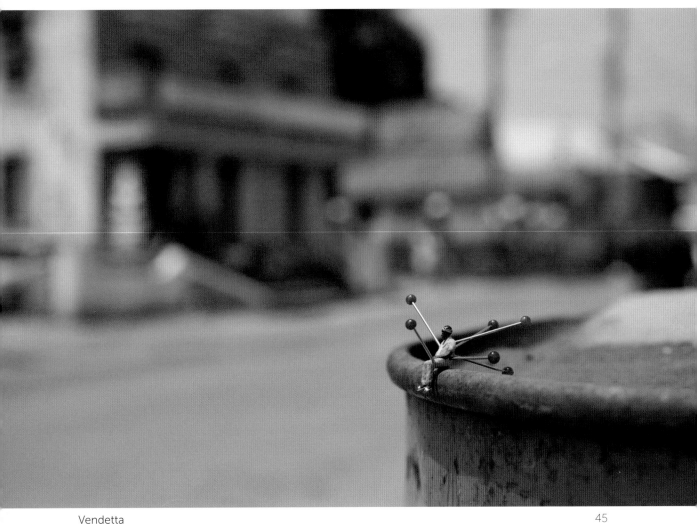

Vendetta

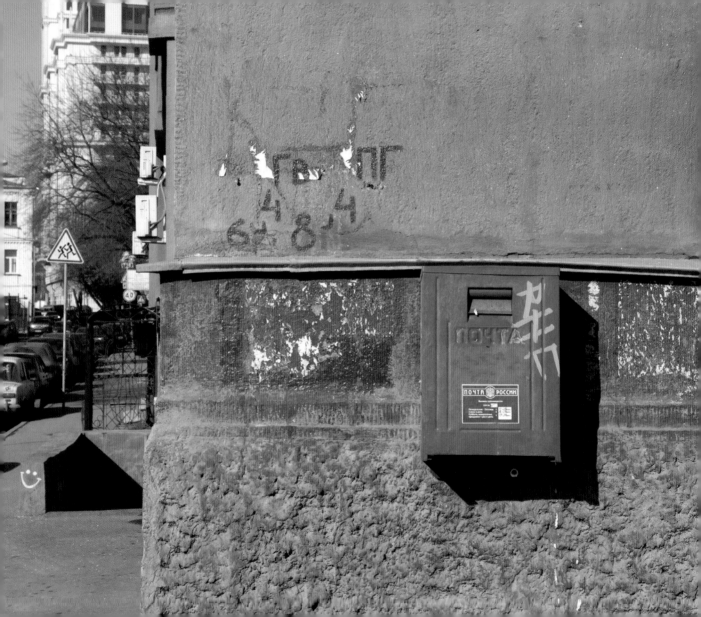

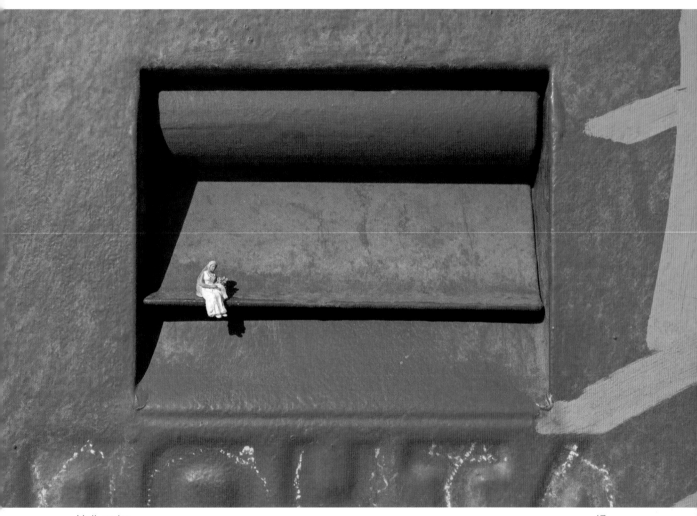

Mail-order

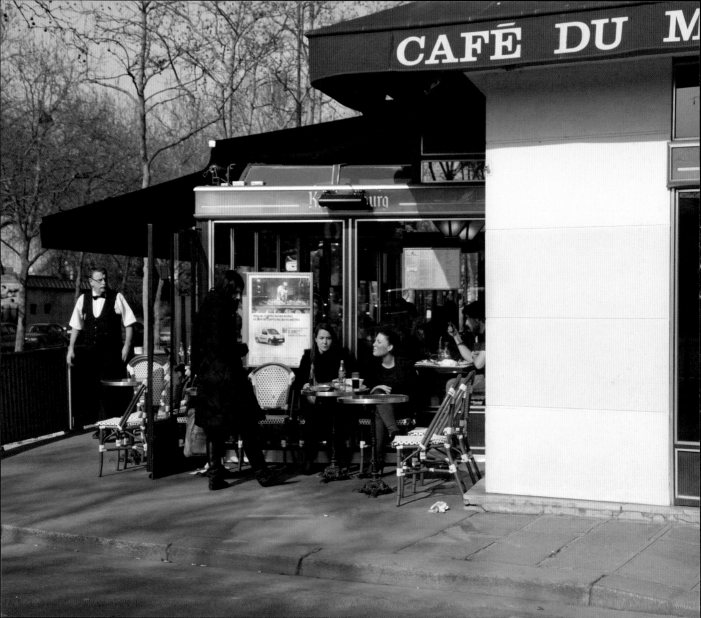

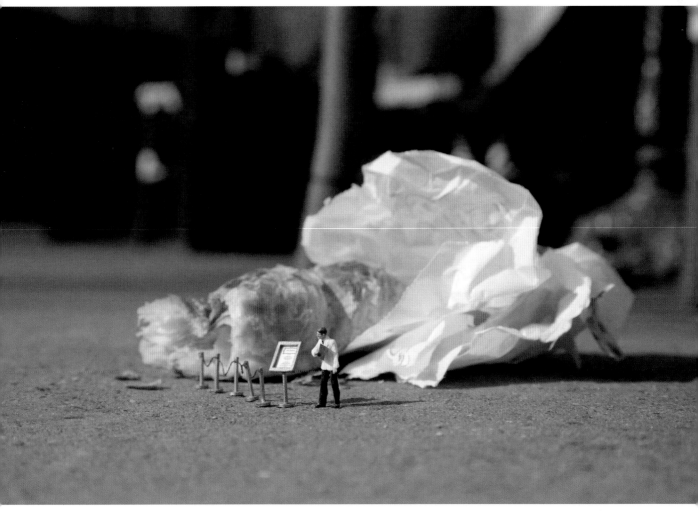

Reservations

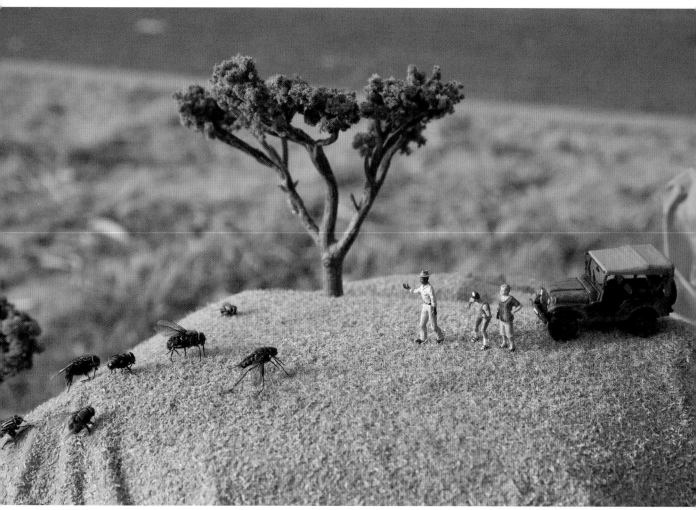

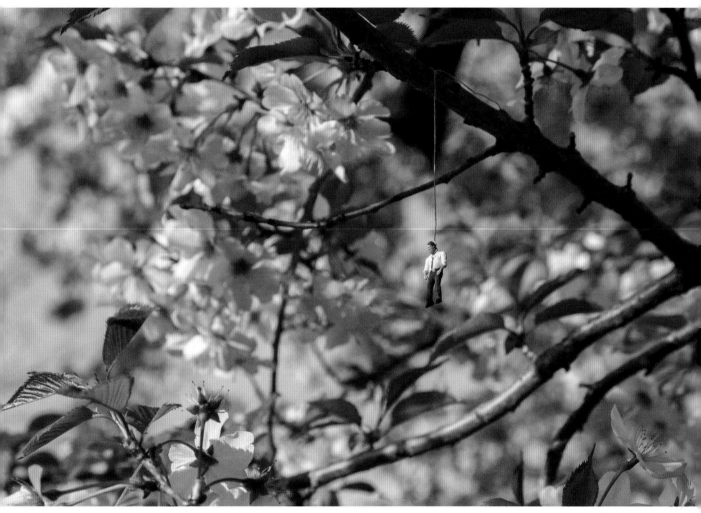

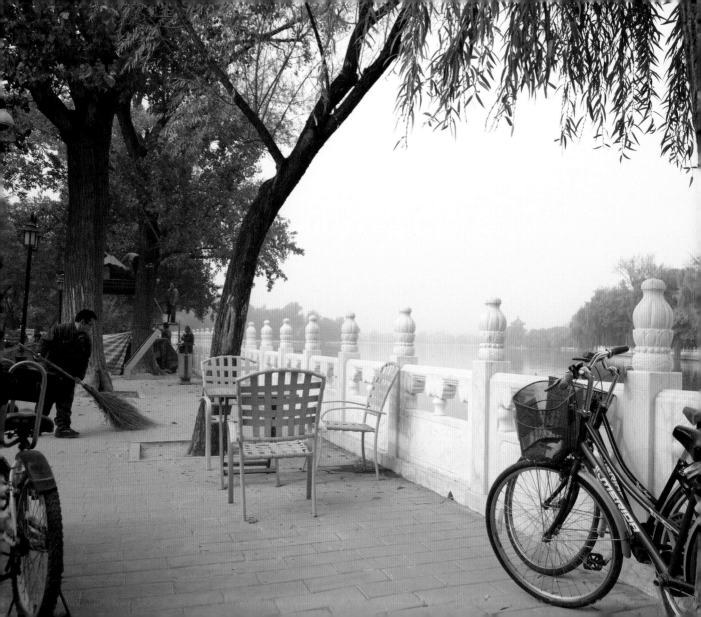

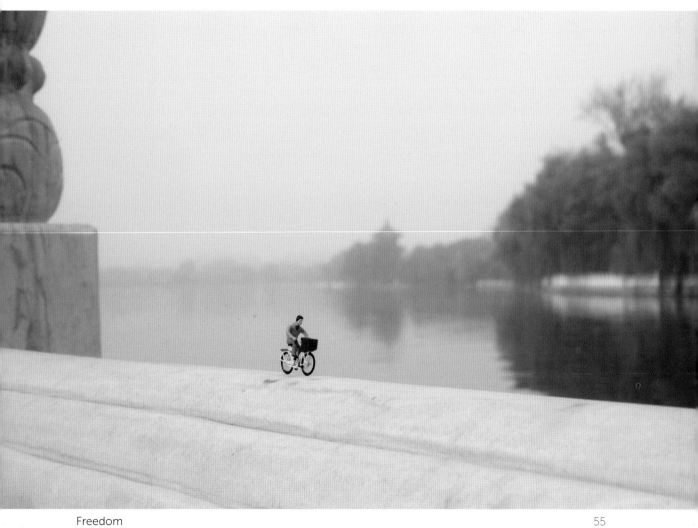

Freedom

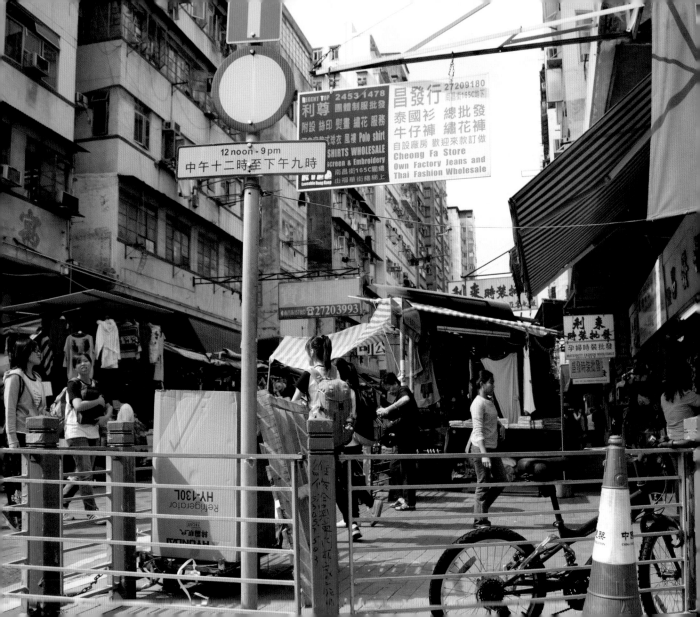

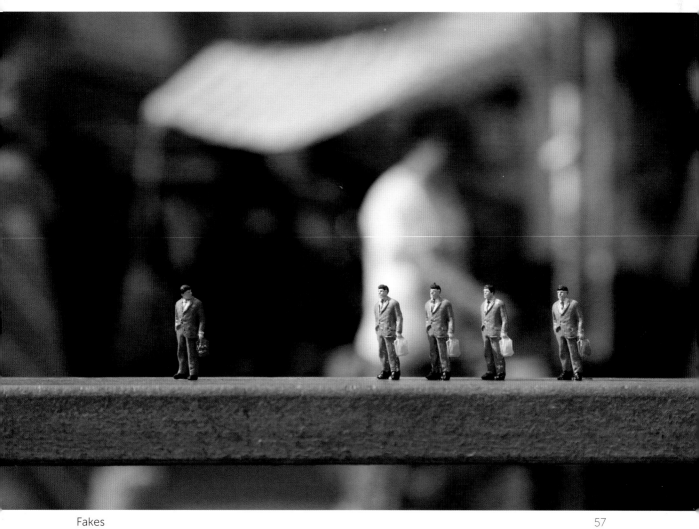

Fakes

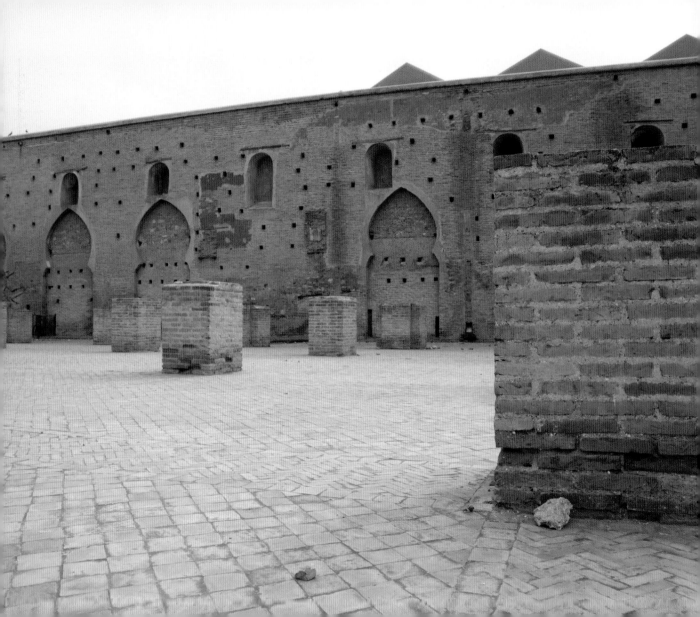

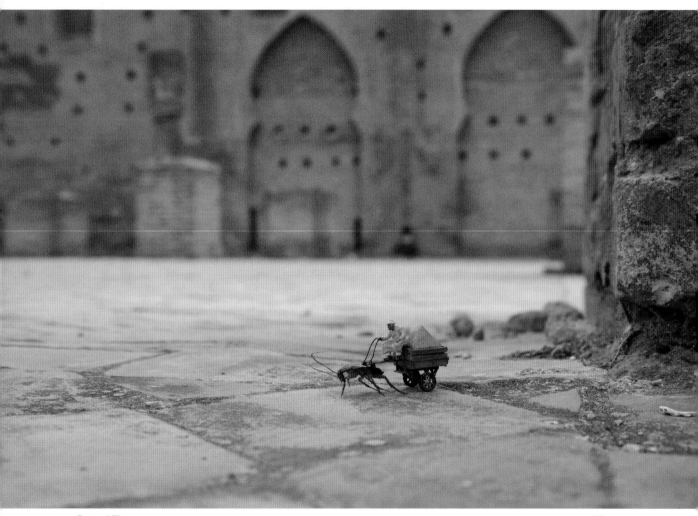

Out of Time

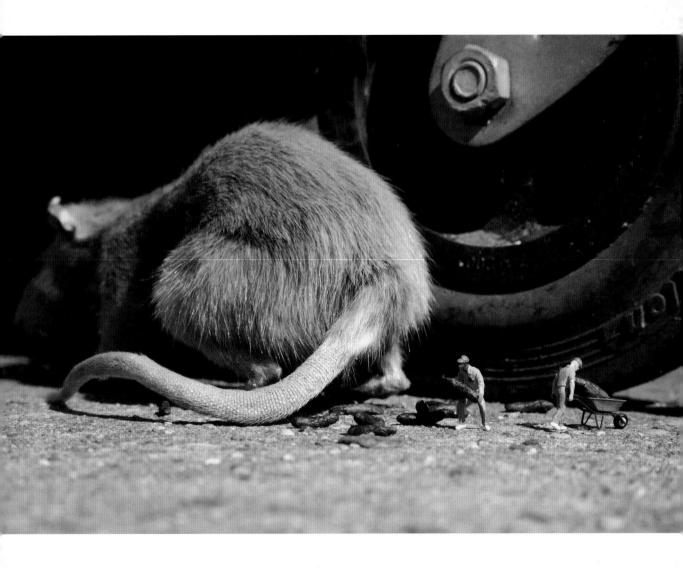

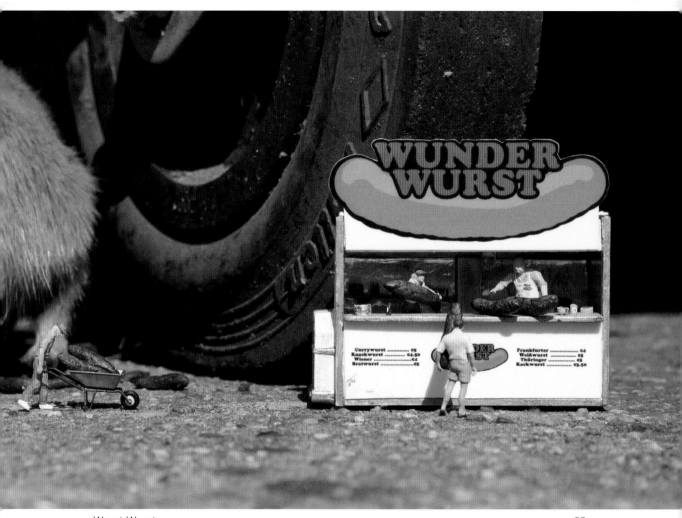

Worst Wurst

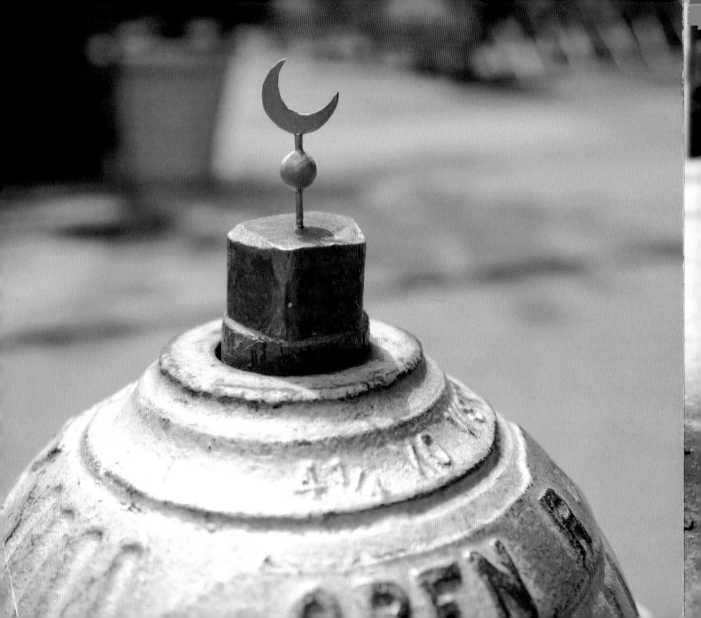

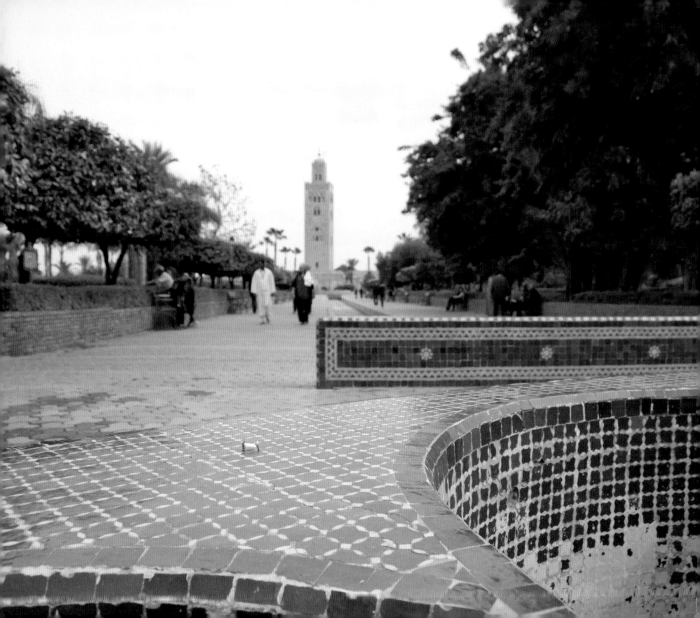

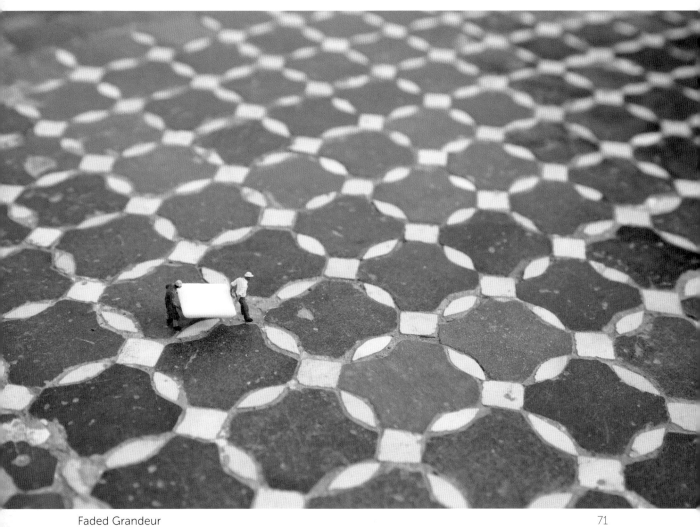

Faded Grandeur

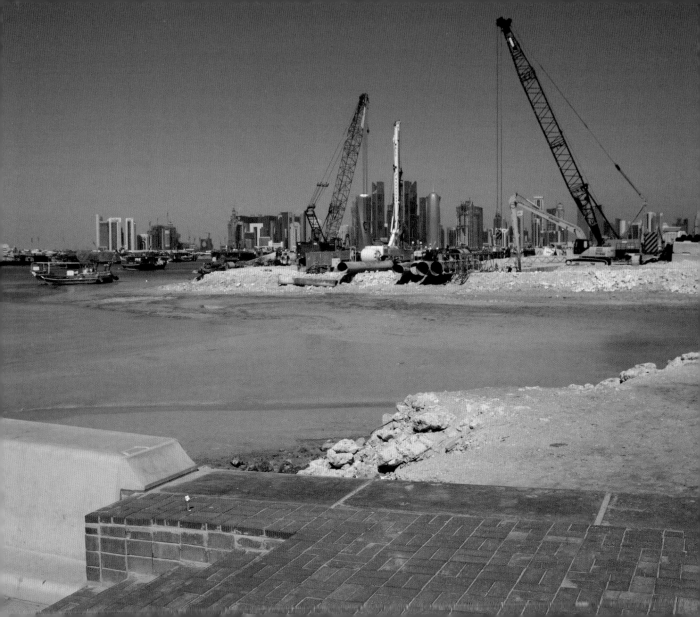

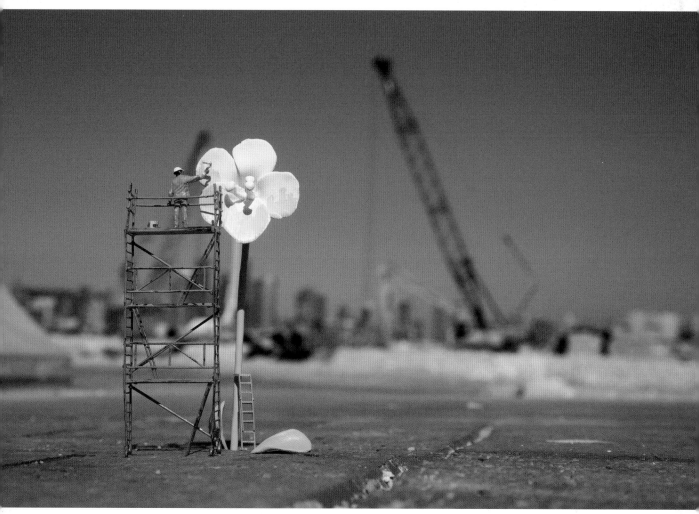

Natural Resources

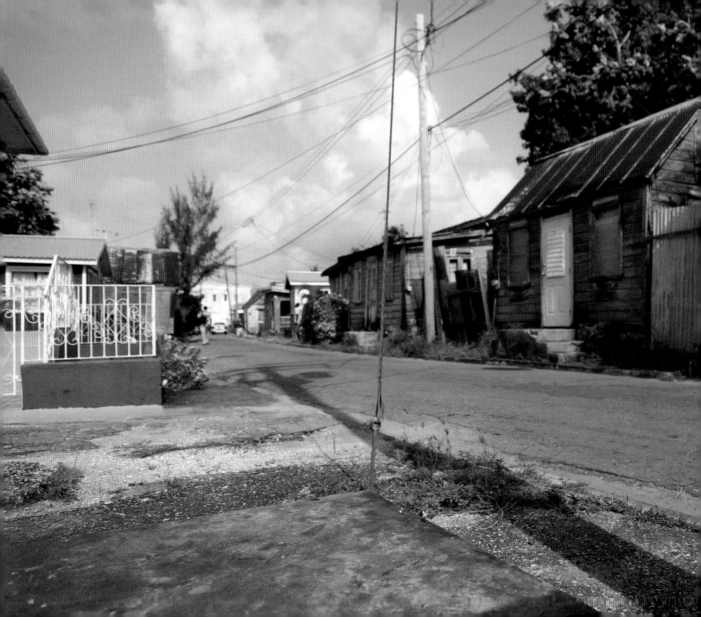

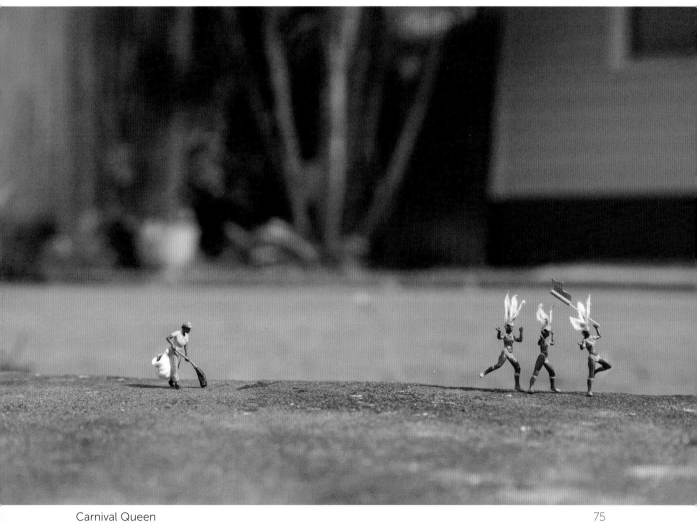

Carnival Queen

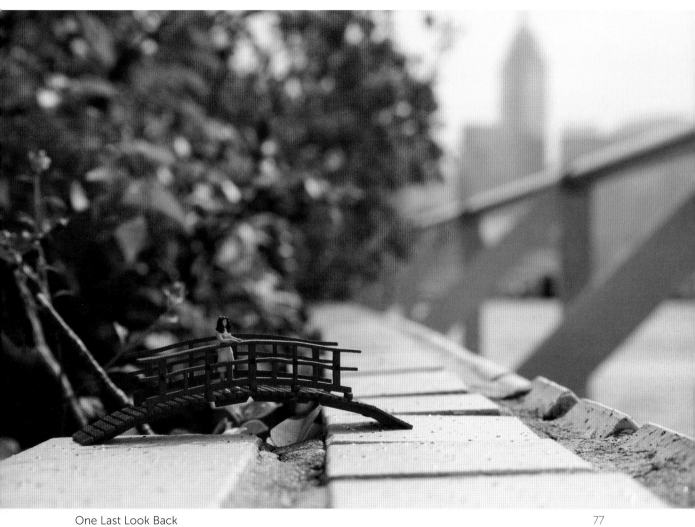

One Last Look Back

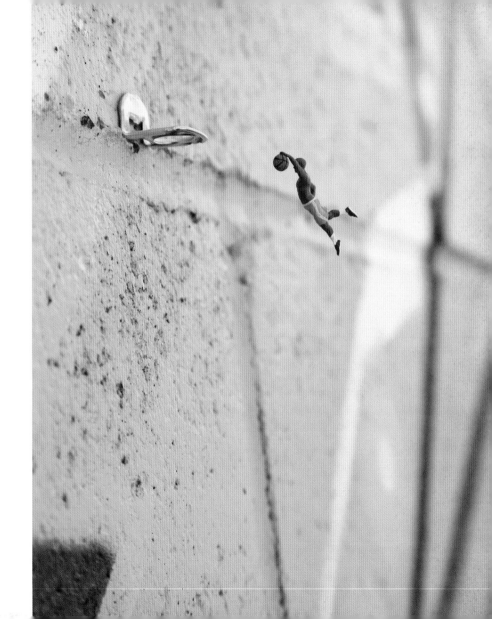

All-Star Nobody

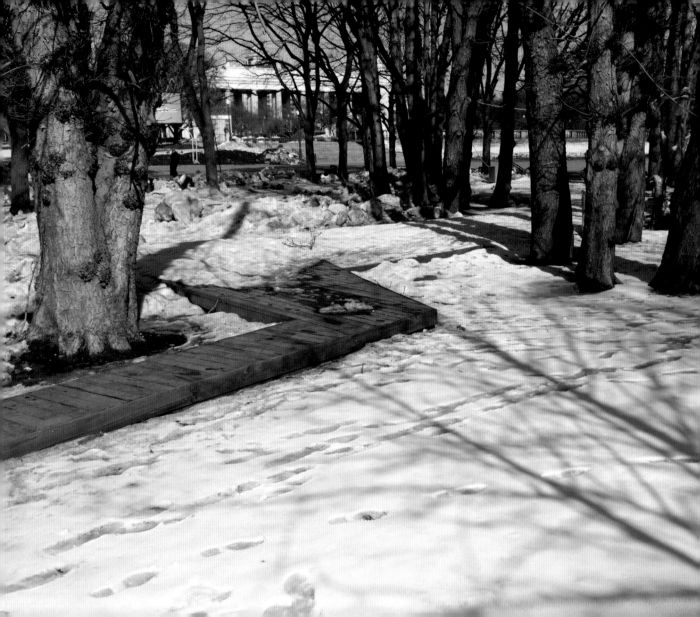

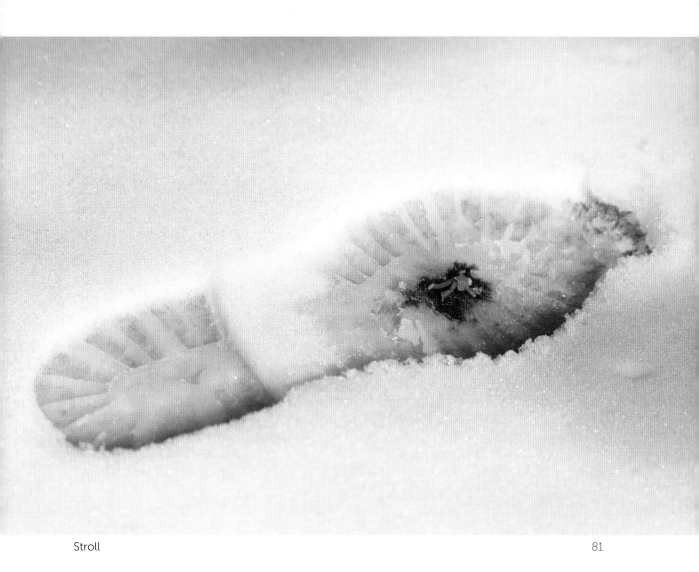

Stroll

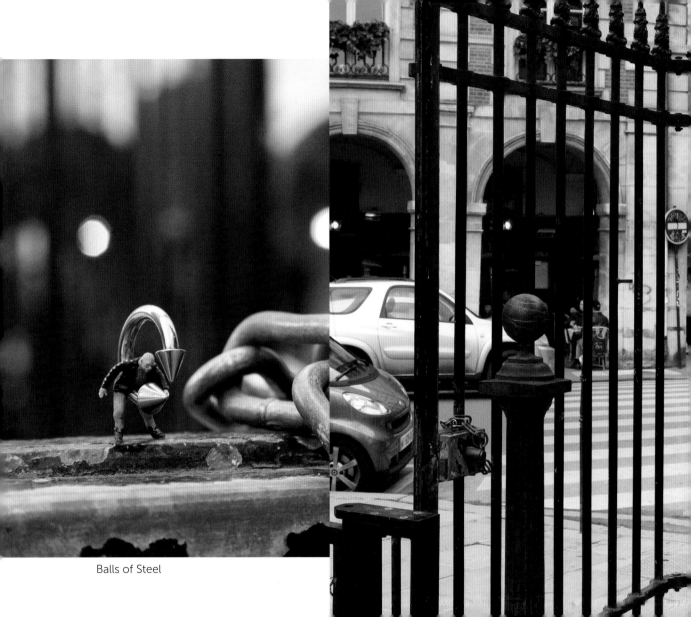

Balls of Steel

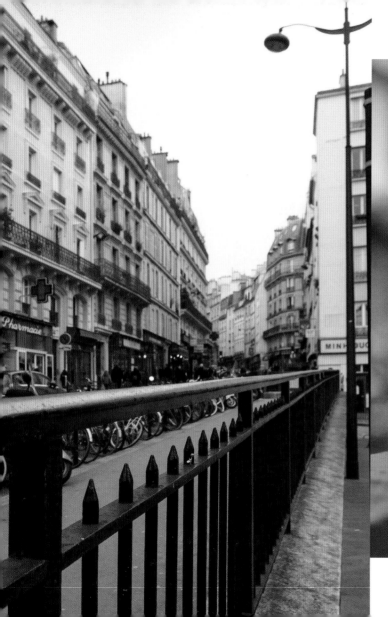

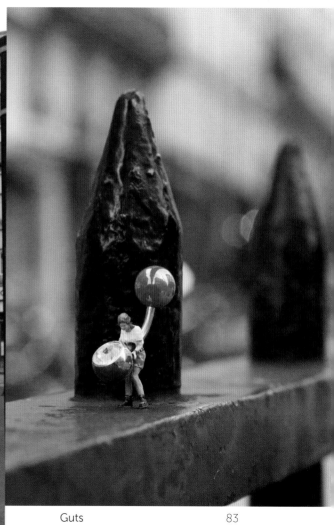

Guts 83

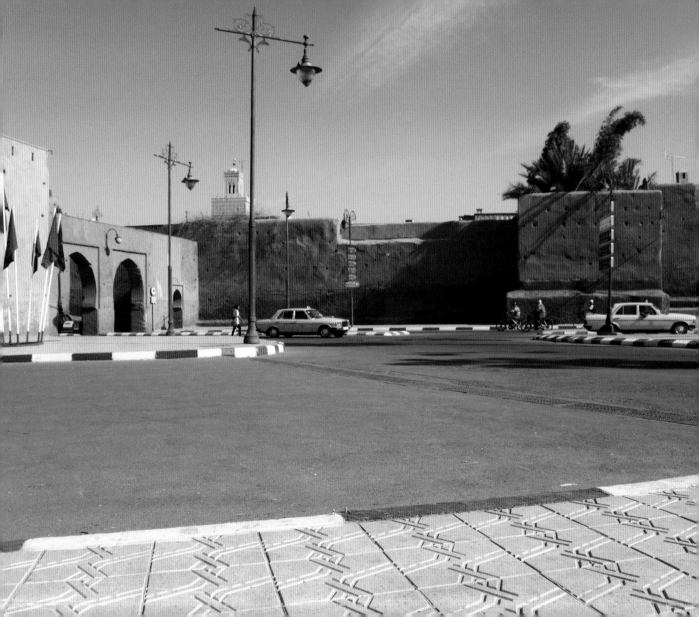

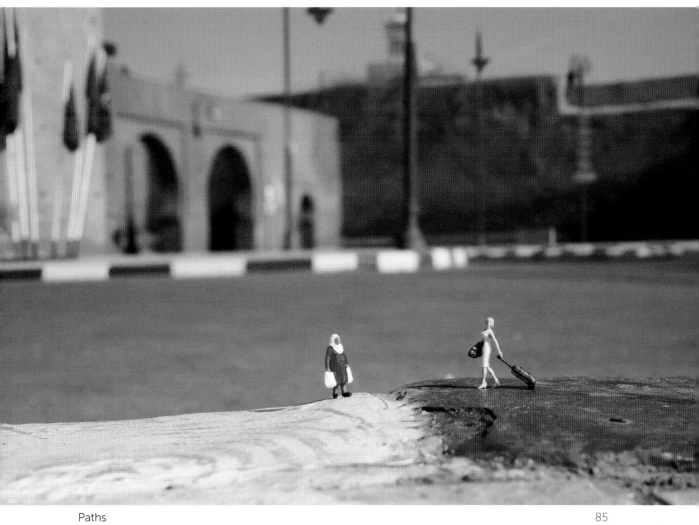

Paths

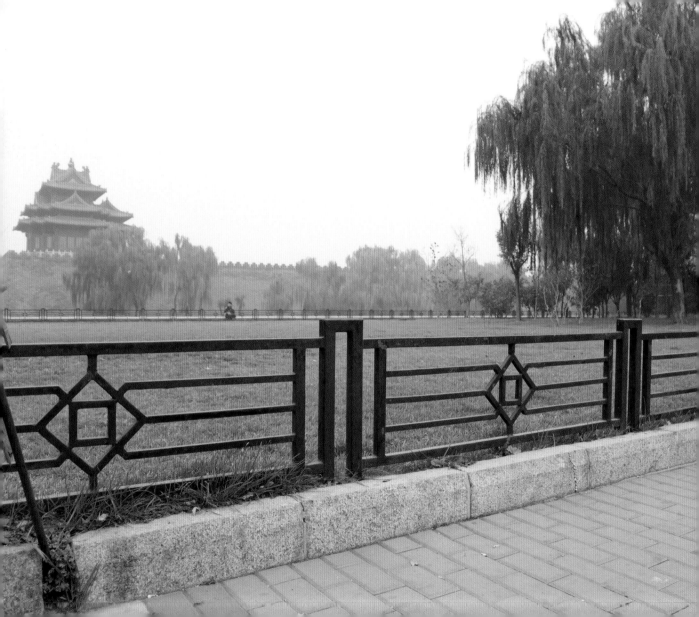

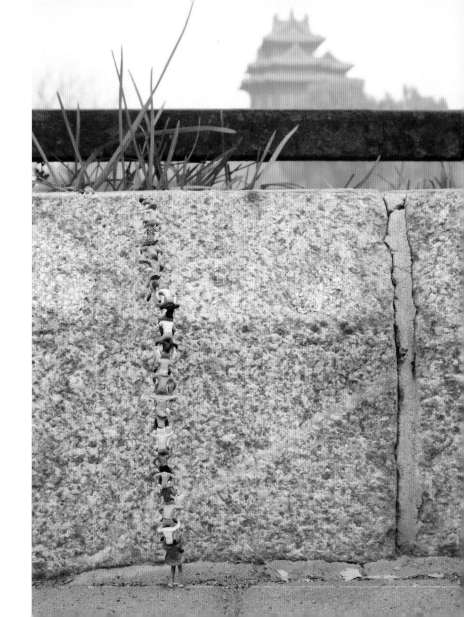

Great Wall

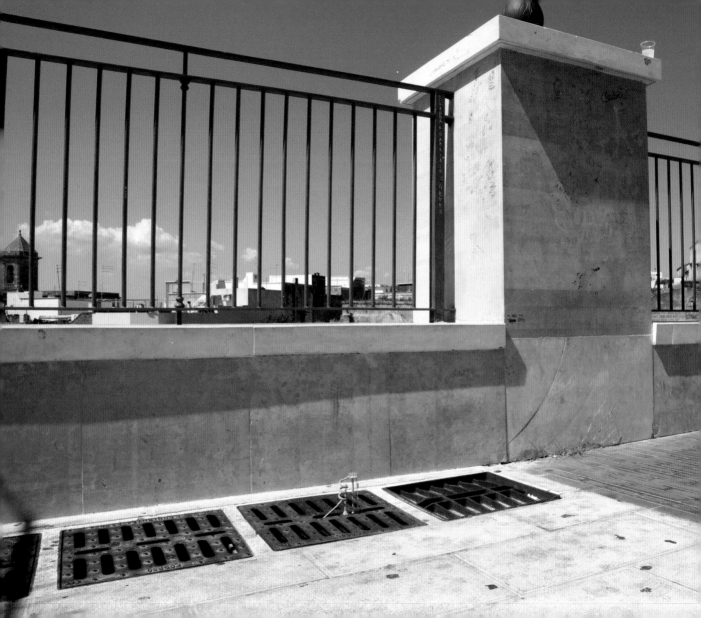

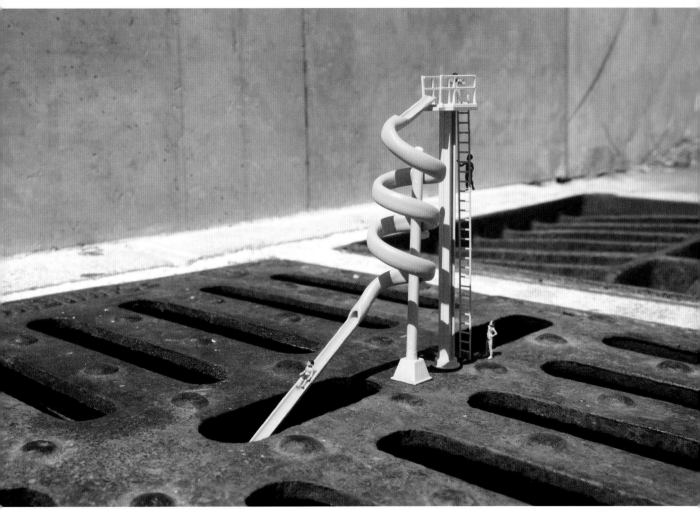

Wet 'n' Wild

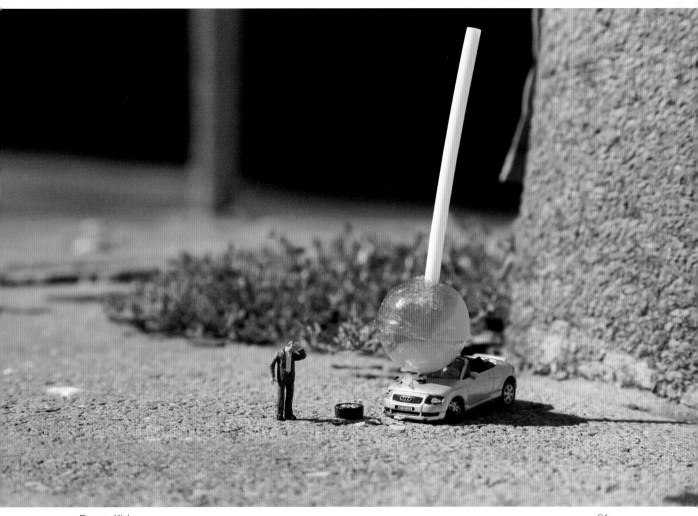

Damn Kids

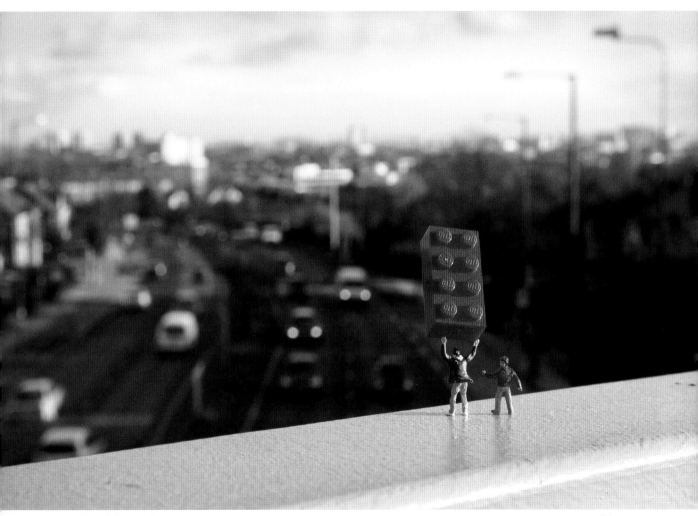

Boys' Own Adventures

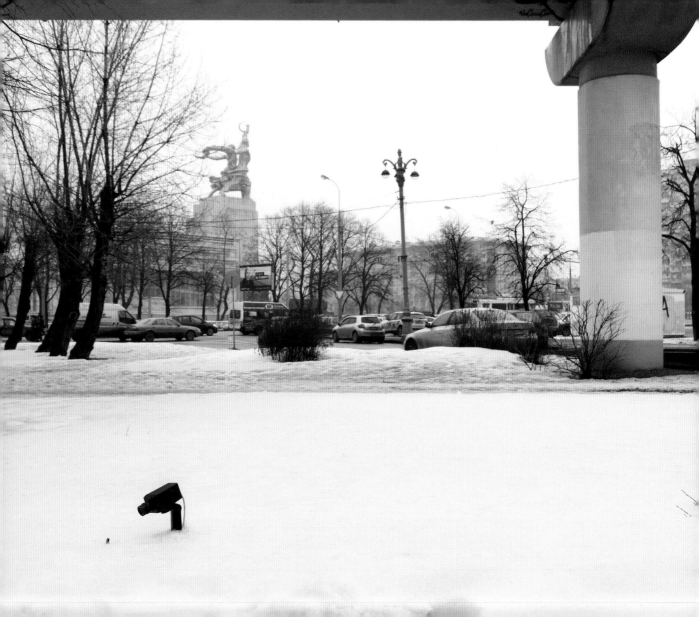

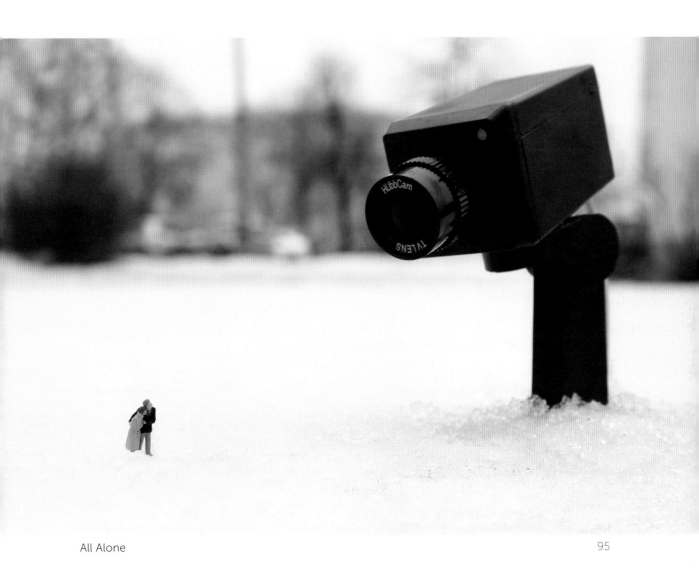

All Alone

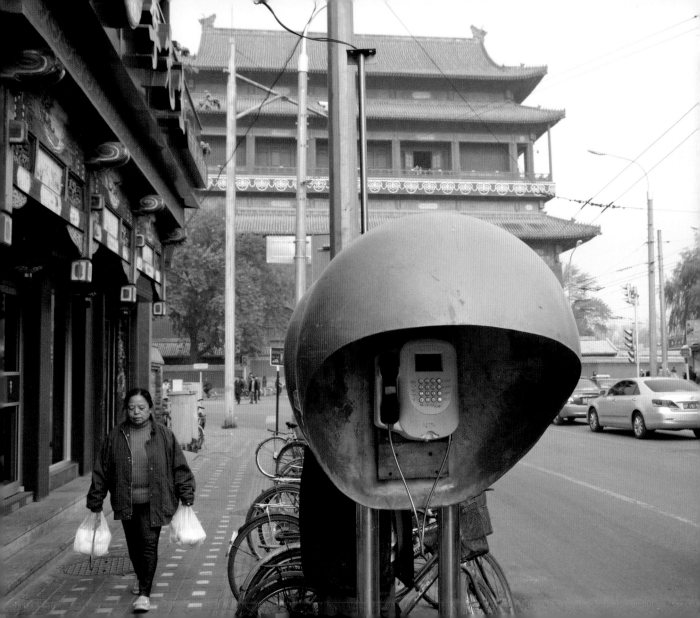

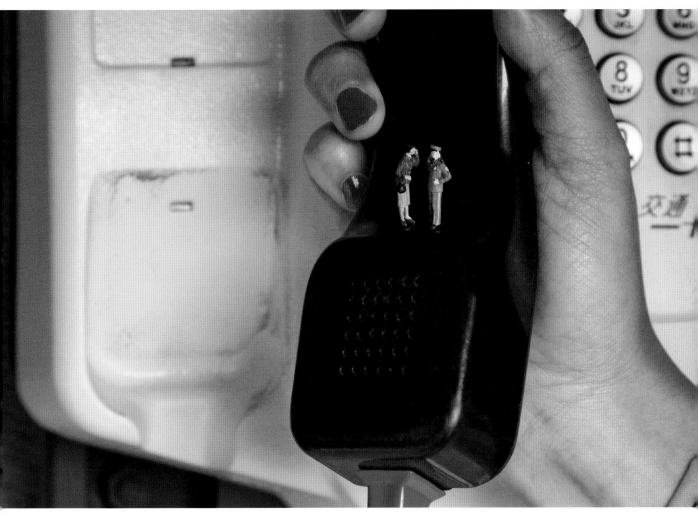

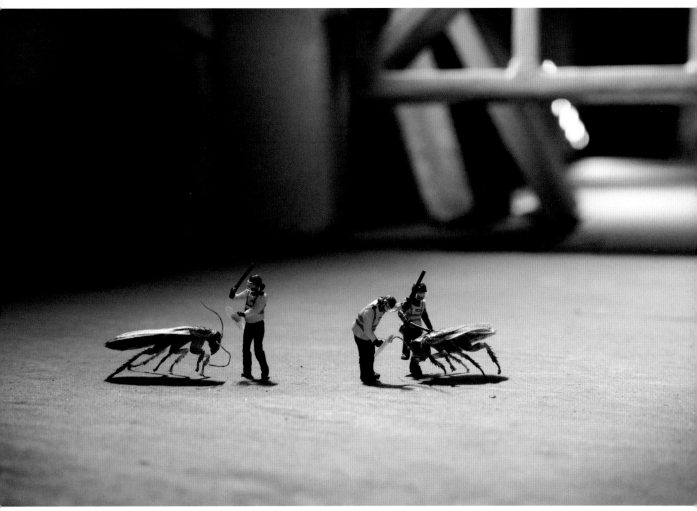

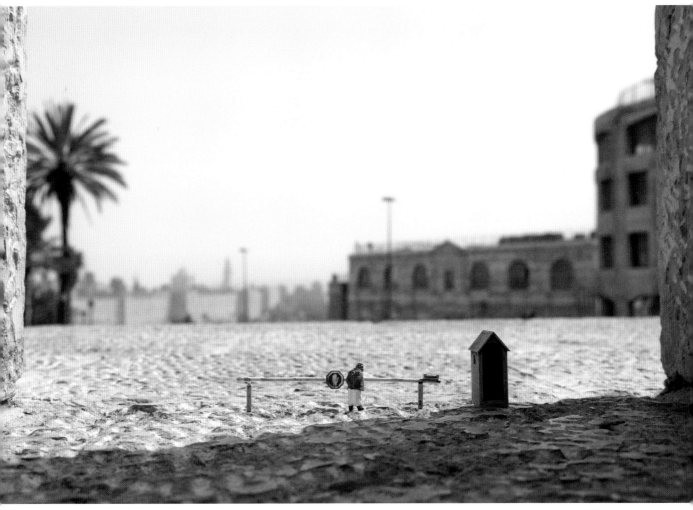

No Man's Land

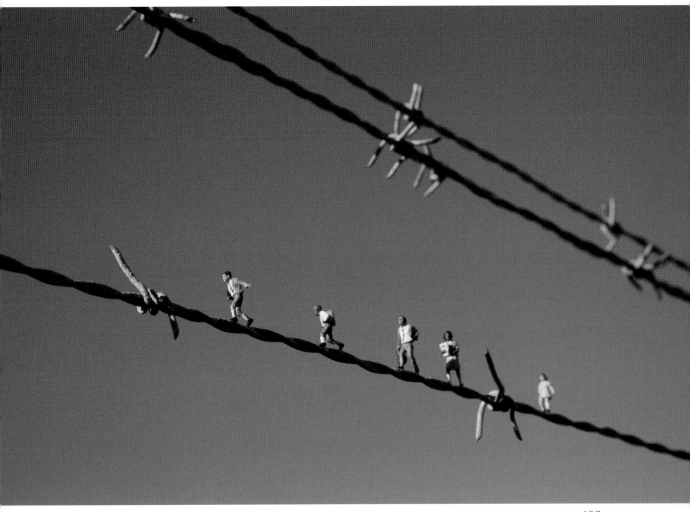

School Run

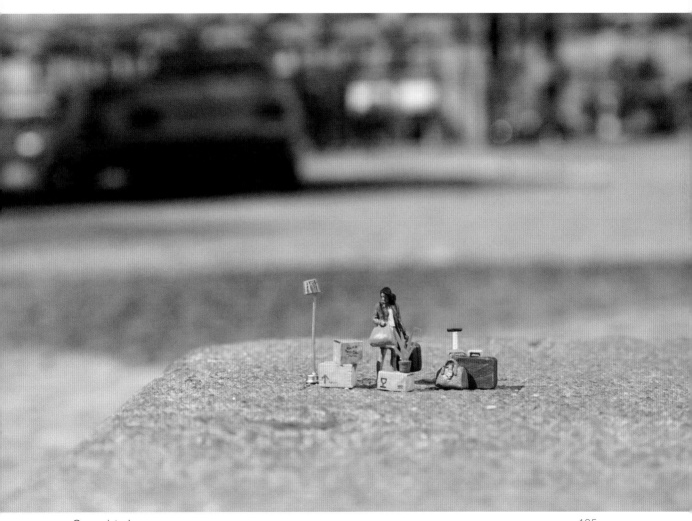

Conquistador

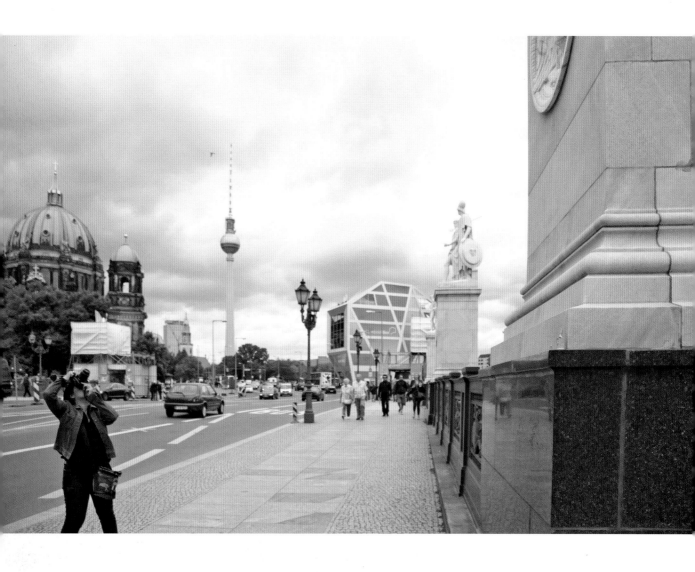

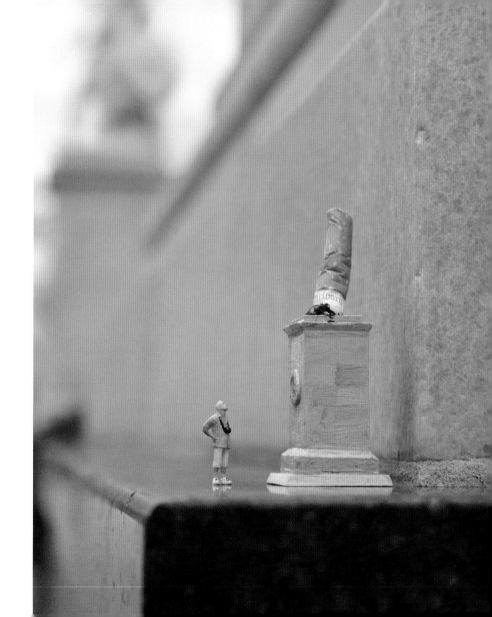

History

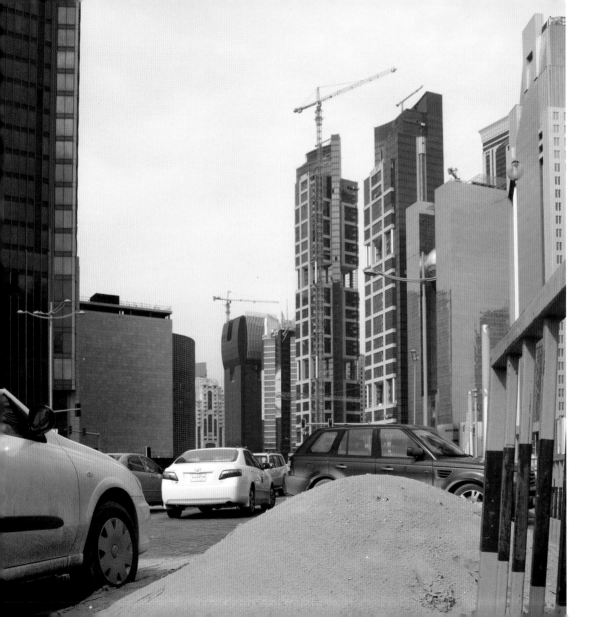

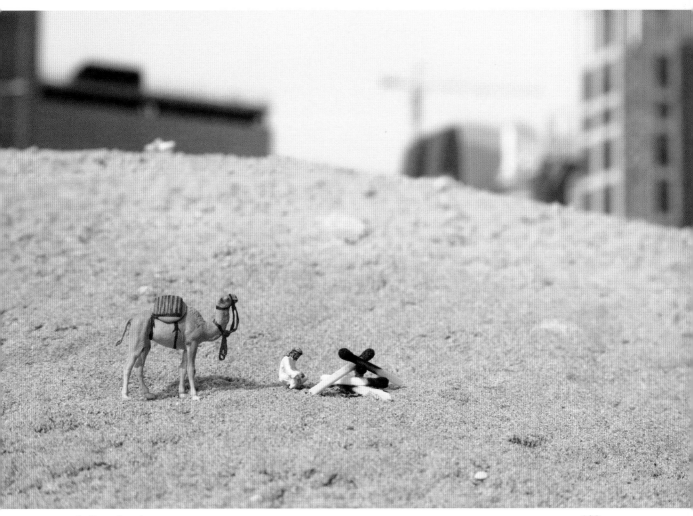

Antique Land

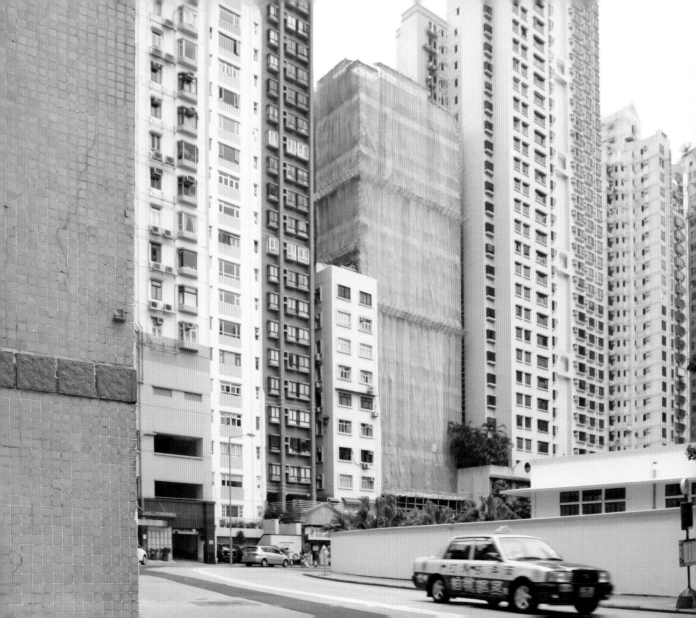

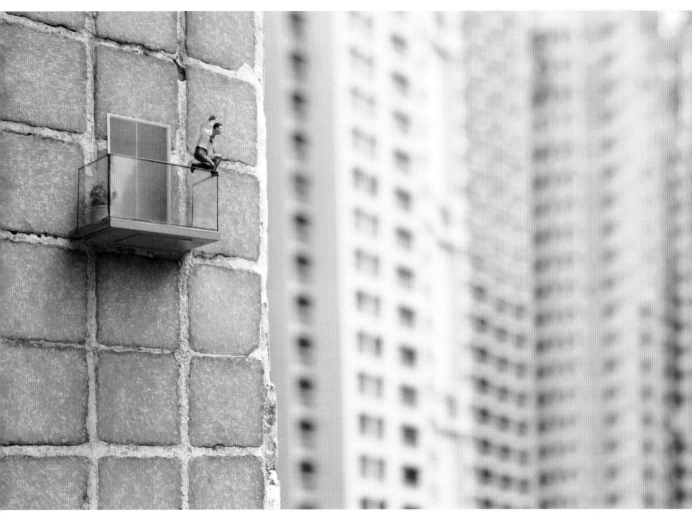

Exit Strategy

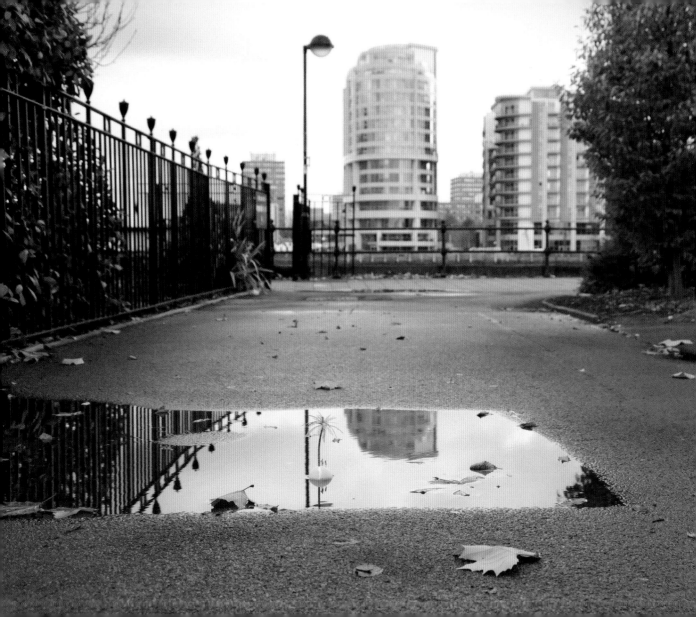

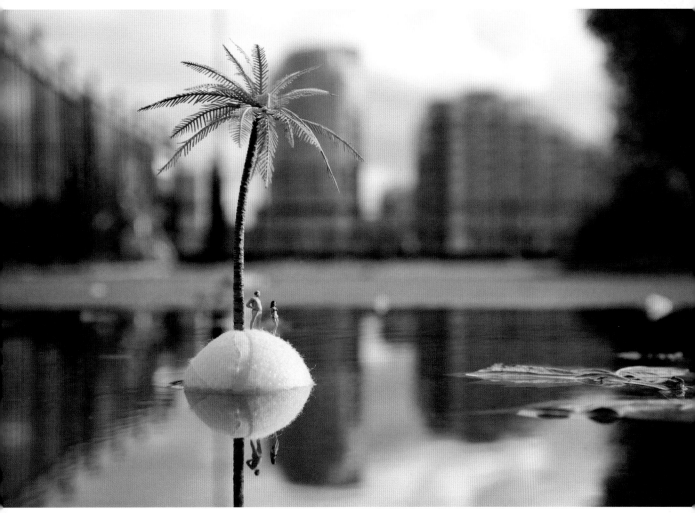

The Last Resort

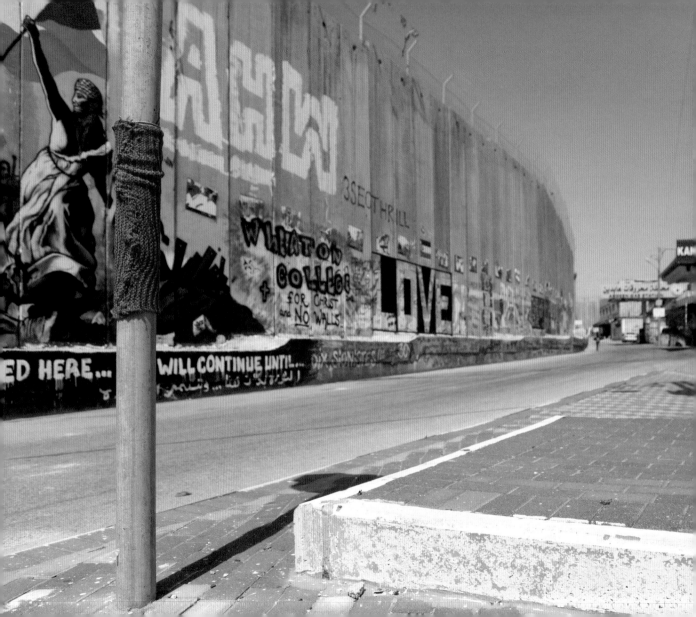

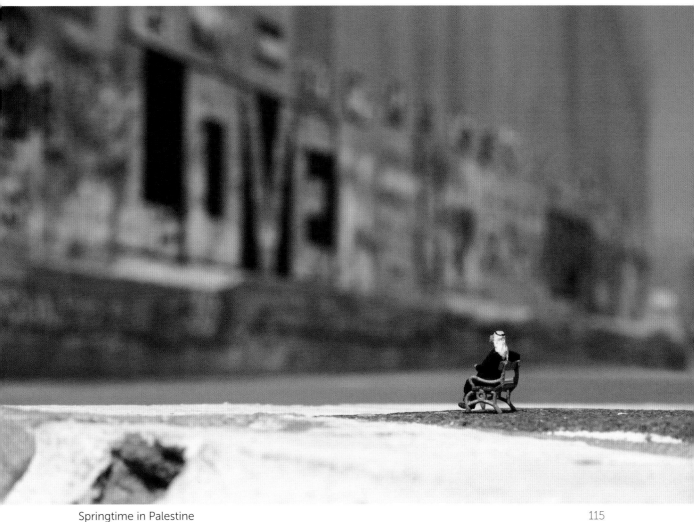

Springtime in Palestine

**INDEX**

pp.12–13

**Skyscraping**

Brooklyn Bridge
Park, New York,
USA, 2011

pp.14–15

**Industrial
Revolutions**

Weesperbuurt en
Plantage area,
Amsterdam,
Netherlands, 2010

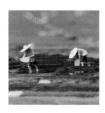

pp.16–17

**The Food Chain**

Gui jie
(Ghost Street),
Beijing, China, 2011

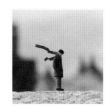

pp.18–19

**Into the Wind**

Bolshoy
Moskvoretskiy
Bridge
(Red Square/
Kremlin), Moscow,
Russia, 2012

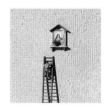

pp.20–21

**The Local Authority**

Grottaglie, Italy,
2010

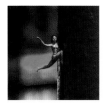

pp.22–23

**Hanging On**

Mong Kok,
Kowloon,
Hong Kong, 2011

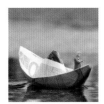

pp.24–25

**Early Mid-life Crisis**

Reichstag, Berlin,
Germany, 2011

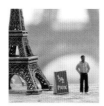

pp.26–27

**Economies of Scale**

Trocadéro, Paris,
France, 2012

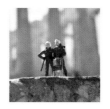

pp.28–29

**The Sights**

The Acropolis,
Athens, Greece,
2010

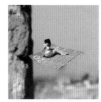

pp.30–31

**Single Journey**

View from the
El Badi Palace,
Marrakech,
Morocco, 2010

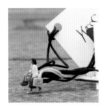

pp.32–33

**Branded**

Saint-Germain-
des-Prés, Paris,
France, 2012

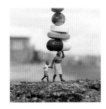

pp.34–35

**Balancing Act**

Khayelitsha
township,
Cape Town,
South Africa,
2011

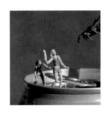

pp.36–37

**Pest**

Bairro Alto area,
Lisbon, Portugal,
2011

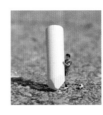

pp.38–39

**Sidelines**

Kerem HaTeimanim,
Tel Aviv, Israel, 2012

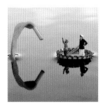

pp.40–41

**Fantastic Voyage**

Acton, London,
UK, 2011

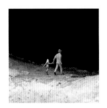

pp.42–43

**The Cave**

Grottaglie, Italy,
2010

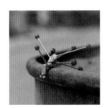

pp.44–45

**Vendetta**

Bridgetown,
Barbados, 2011

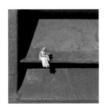

pp.46–47

**Mail-order**

Gorky Park area,
Moscow, Russia,
2012

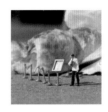

pp.48–49

**Reservations**

7th Arrondissement,
Paris, France, 2012

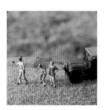

pp..50–51

**Wild Life**

Ocean View,
Cape Town,
South Africa, 2011

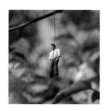

pp.52–53

**Wonderful World**

Shepherd's Bush,
London, UK, 2012

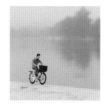

pp.54–55

**Freedom**

Houhai, Beijing,
China, 2011

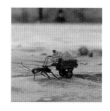

pp.56–57

**Fakes**

Tai Kok Tsui,
Kowloon,
Hong Kong, 2011

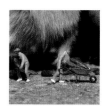

pp.58–59

**Out of Time**

Arset El Bilk,
Marrakech,
Morocco, 2010

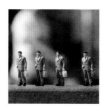

pp.60–62

**Worst Wurst**

Central Stuttgart,
Germany, 2011

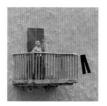

pp.63–66

**What Brings Us
Together and What
Keeps Us Apart**

Grottaglie, Italy,
2009

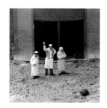

pp.67–69

**House of God
(Application to
the Department
of City Planning –
Ref: 13-3470/C)**

Tribeca, New York,
USA, 2011

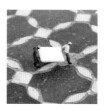

pp.70–71

**Faded Grandeur**

Lalla Hasna Park,
Marrakech,
Morocco, 2010

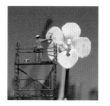

pp.72–73

**Natural Resources**

The Corniche,
Doha, Qatar, 2011

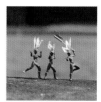

pp.74–75

**Carnival Queen**

Bridgetown,
Barbados, 2011

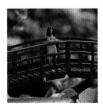

pp.76–77

**One Last Look Back**

Tsim Sha Tsui,
Kowloon,
Hong Kong, 2011

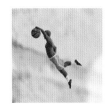

pp.78–79

**All-Star Nobody**

Williamsburg,
Brooklyn, New York,
USA, 2011

pp.80–81

**Stroll**

Gorky Park,
Moscow, Russia,
2012

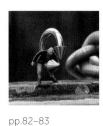

pp.82–83

**Balls of Steel**

*Guy:* Place des
Vosges, Paris,
France, 2012

**Guts**

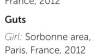

*Girl:* Sorbonne area,
Paris, France, 2012

pp.84–85

**Paths**

Bab er Robb,
Marrakech,
Morocco, 2010

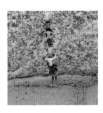

pp.86–87

**Great Wall**

Near the
Forbidden City,
Xicheng district,
Beijing, China,
2011

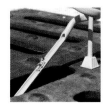

pp.88–89

**Wet 'n' Wild**

Grottaglie, Italy,
2010

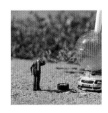

pp.90–91

**Damn Kids**

Rathaus area,
Stuttgart, Germany,
2011

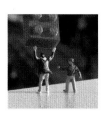

pp.92–93

**Boys' Own
Adventures**

Acton, London,
UK, 2011

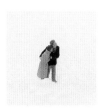

pp.94–95

**All Alone**

VDNKh area,
Moscow, Russia,
2012

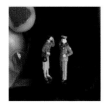

pp.96–97

**Whispers**

Drum Tower,
Dongcheng district,
Beijing, China, 2011

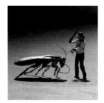

pp.98–99

**Animals**

Wandsworth,
London, UK, 2011

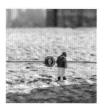

pp.100–101

**No Man's Land**

Near the New Gate,
Jerusalem, Israel,
2012

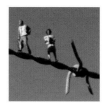

pp.102–103

**School Run**

District 6,
Cape Town,
South Africa, 2011

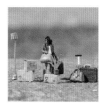

pp.104–105

**Conquistador**

Alfama district,
Lisbon, Portugal
2011

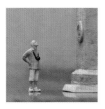

pp.106–107

**History**

Schlossbrücke,
Berlin, Germany,
2011

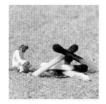

pp.108–109

**Antique Land**

City centre,
Doha, Qatar, 2011

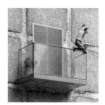

pp.110–111

**Exit Strategy**

Mid-levels area,
Hong Kong, China,
2011

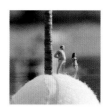

pp.112–113

**The Last Resort**

Wandsworth,
London, UK, 2010

pp.114–115

**Springtime in
Palestine**

West Bank
separation wall,
Bethlehem,
Palestinian
territories, 2012

## AFTERWORD

This book isn't a definitive 'Slinkachu World Tour'. Instead it is a collection of work shot in a number of cities over the past few years, sometimes as part of a foreign show, sometimes while just on a weekend getaway and sometimes specifically to include in these pages. There are many other cities that I would like to have visited, but they will have to wait. I thought Kabul might be interesting, for instance, but was advised by a photographer who regularly visits Afghanistan that my style of shooting – lying in the street for half an hour – would be an open invitation to kidnappers. Best to ride a dirt bike, wear a helmet to hide your face and shoot on the move, apparently. So I went to Barbados with my mum and dad instead.

## ACKNOWLEDGMENTS

The works in this book might have been possible without the help, support, patience and enthusiasm of the following people and organisations, but life would have been a whole lot lonelier.

A big thanks to:

My editor Jon Butler and the guys at Pan Macmillan, the team at Hoffmann Und Campe, Oscar van Gelderen and the team at Lebowski Publishers, and the guys at Blue Rider Press – for this book, the first book and the one in between. Acoris Andipa and the guys at Andipa Gallery for their continued support. Angelo Milano from Studiocromie for FAME Festival (x2!) in Grottaglie. Noa Kessler for the bed, hummus and cats in Tel Aviv. Matt de Pass for hanging out with me in New York. Hilary Moore for tours of Cape Town's scariest places. Andrea Wolter-Abele and the team at Kunstverein Ludwigsburg, and Thiemo Hehl, for the show, Stuttgart and wurst. Aoibheann and Paul Hopkins from Maison MK for their beautiful riad in Marrakech. Volker Preiser and the Preiser company for their amazing figures, the tour and the last-minute camels. Shakira (RIP) for always being there, until you died. Mum, Dad and Kerry for sun and turtles. All my friends – you know who you are – for your support, encouragement and criticism over the years. And finally Gretch, for all the hotel bookings, all the flights, all the apps, all the online reviews, all the filming, all the cold, all the patience and all the food we nom nom nommed along the way. I was never truly alone xoxo

3 1901 05413 0788